DISCOVERING ART

The Life, Times and Work of the World's Greatest Artists

KLIMT

D. M. GILL

BROCKHAMPTON PRESS

For MG
Now and Always

First published in Great Britain by Brockhampton Press,
an imprint of The Caxton Publishing Group,
20 Bloomsbury Street, London WC1B 3JH

ISBN 1 84186 094 8

Produced by Flame Tree Publishing ,
The Long House, Antrobus Road, Chiswick, London W4 5HY
for Brockhampton Press
A Wells/McCreeth/Sullivan Production

Pictures printed courtesy of the Visual Arts Library, London,
Edimedia, Paris, and the Bridgeman Art Library, London.

Printed and bound by Oriental Press, Dubai

CONTENTS

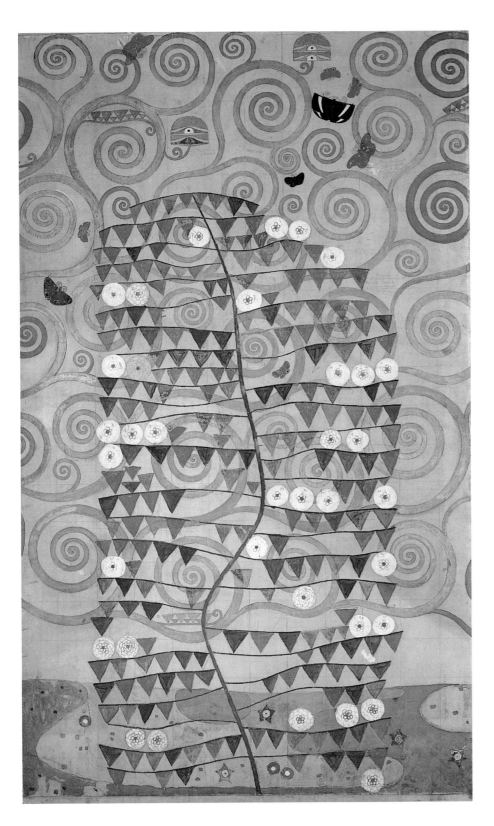

Chronology 6

The Early Years:
1862 to 1900 8

Artist Alone:
1900 to 1918 24

Drawings,
Landscapes
and Portraits 40

Allegories 60

Index 80

Selection of Prints 81

Draft for the Stoclet Frieze (Austrian Museum of Applied Art, Vienna).

CHRONOLOGY

1862 Gustav Klimt born in Vienna.

1876 Enters Vienna Art School.

1879 Contributes to decorations for pageant celebrating silver wedding of Emperor Franz Joseph and Empress Elizabeth. Gustav, his brother Ernst, and their friend Franz Matsch form *Künstlercompagnie*.

1881 Contributes to Allegories and Emblems.

1883 *Künstlercompagnie* sets up studio at 8 Sandwirthgasse.

1886 Begins work on decorations for new Burgtheater.

1890 Commissioned to provide decorations for Museum of Art History.

1891 Becomes member of Co-operative Society of Austrian Artists.

1892 Moves to bigger studio at 21 Josefstädterstrasse. Death of father and brother Ernst.

1894 Commissioned to decorate ceiling of Great Hall of Vienna University.

1895 Paints *Love*.

1897 Foundation of Secession Movement.

1898 First Secession Exhibition and first appearance of Secession monthly magazine, *Ver Sacrum*.
 Paints *Sonja Knips* and *Pallas Athene*.

1899 Completes decoration of Dumba Palace Music Room.
 Paints *Nudas Veritas* and *Schubert at the Piano*.

1900 First painting for Vienna University, *Philosophy*, exhibited unfinished at Paris World Fair and wins Grand Prix.
 Paints *Rose von Rosthorn-Friedmann*.

1901 Paints *Medicine* and *Judith and Holofernes*.

1902 *Beethoven Frieze* accompanies Max Klinger's statue of Beethoven in Secession building.
 Paints *Emilie Flöge*.

1903 Wiener Werkstätte founded by Joseph Hoffman and Koloman Moser. Klimt travels to Ravenna and Florence.
 Paints *Jurisprudence*.

1904 Commissioned to paint frieze for Stoclet House in Brussels.
 Paints *Water Snakes*.

1905 Klimt withdraws from Secession movement. Paints *Three Ages of Woman*.

1907 Paints *Danae* and *Adele Bloch-Bauer*.

1908 Paints *The Kiss*.

1909 Paints *Judith II* and *Hope*.

1911 Klimt travels to Rome and Florence. Paints *Death and Life*.

1914 Outbreak of First World War. Paints *Elisabeth Bachofen-Echt*.

1917 Begins *Baby* (unfinished).

1918 Death of Klimt.

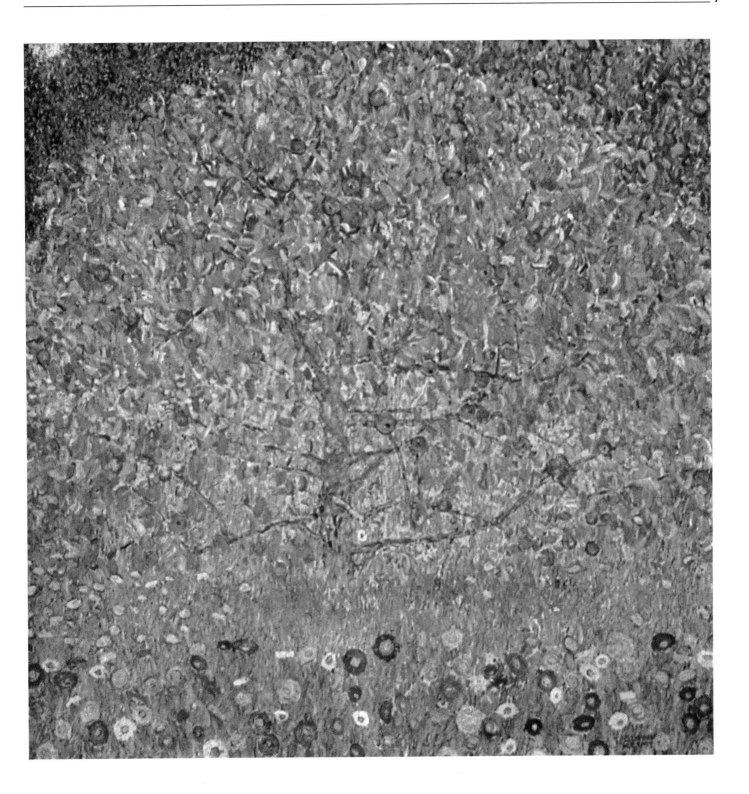

Apple Tree I, *c.* **1912** (Museum of the Twentieth Century, Vienna). This close-up of an apple tree spangled with golden fruit fills the canvas. The paint is layered to create an impression of depth despite the narrow focus.

CHAPTER 1

The Early Years: 1862 to 1900

Gustav Klimt lived at an especially fascinating and climactic period of European history. Born in 1862, he spent his life in Vienna, a city which underwent many fundamental changes during his lifetime.

A spacious, self-indulgent city, Vienna rivalled Paris and London for culture and prosperity, and its citizens enjoyed a life of colour, glamour and music. The city was famous for its waltzes and operettas composed by Richard and Johann Strauss, its fabulous balls, its cafés, its Sachertorte. The Emperor Franz Josef was commander-in-chief of the brilliantly plumaged Imperial Habsburg Army, famous more for its brightly coloured uniforms than for any military distinction.

The physical face of Vienna underwent major changes in the second half of the nineteenth century, both at the centre of the city and beyond. The old city walls were demolished in the 1850s, and the military training and exercise area beyond was used for the building of a splendid new boulevard. This road was built in a horseshoe shape round the city, and came to be called the Ringstrasse. This was not only an imposing avenue, lined with shady trees and dignified new buildings, but was also a symbol of the value Imperial Vienna placed upon itself.

Both public and private buildings were constructed, vying with each other to be the most magnificent. There was a parliament building, a new church, a stock exchange, a university, theatres and museums; there were private houses, hotels and apartment blocks. Here, at the most fashionable addresses in Vienna, the good burgers of Vienna lived what was a kind of fantasy life. Overwhelmingly, the preference of the Viennese was for ostentation, for show at the expense of substance; behind the ornate façades of the houses the interiors were filled with rococo mirrors, heavy stuffed furniture, swags and bows and frills and silky surfaces. The magnificence of the city's appearance often hid a rather thin reality. The poor of the city were badly paid and inadequately housed. The prim appearance of a good Christian nation concealed a world of sexual promiscuity; in the government offices, the pusillanimous Imperial foreign policy in the Balkans was pursued. This policy, or the compromises and vacillations inherent in it, was to set the scene for the cataclysm of the Great War, when the society and culture Klimt knew were swept away for ever.

At the same time the Austrian bourgeoisie were caught up in the radical economic and political changes of the time. They were not possessed of real political power, having failed during the Revolution of 1848 to throw off the grasp of the absolute monarchy, and in addition the economy of the Habsburg Empire continued to be based mainly on agriculture. Thus while the middle classes were liberal and often wealthy, they lacked the political power which might have helped to change the way the Empire functioned.

Almost unnoticed, however, old beliefs and certainties were already being questioned. Austria was at the centre of the changes

which carried the world forward, both politically and intellectually. Gustav Mahler was using new chromatic harmonies and musical forms. Although the publication of Sigmund Freud's *Interpretation of Dreams* in 1899 seemed at the time to go almost unnoticed, the ideas it promulgated did spread rapidly through the gossipy café society of Vienna and soon became part of a new intellectual thinking which was to carry the life of the city away from the glossy artifice of the nineteenth century and into the turmoil of the twentieth.

Alongside life on the Ringstrasse, science and industry were striding forwards. Vienna was not the only city in Europe to take advantage of the progress in these fields, but it was the first to have electric street lighting, and trams. Otto Wagner's designs for the municipal railway and other public buildings are in striking contrast with the ornate, historicist buildings going up on the Ringstrasse. Wagner's clean lines and use of modern material look forward to the

Fable, 1883 (detail) (Historical Museum, Vienna). This work derives from Renaissance and Medieval symbolism and attempts to recast it for a contemporary European audience. It is quite unlike his later work.

architecture of the post-war years. It was into this enlightened and aesthetic environment that Klimt was born; in a culture and an era which would provide fodder for one of the most creative minds Vienna would ever witness.

Gustav Klimt was born to art. His father, Ernst Klimt, was Bohemian; his family, of peasant stock, had emigrated to Austria in search of work, and Ernst had grown up to be a goldsmith and engraver. Ernst Klimt married a local girl, Anna Finster, who had hoped to be an opera singer; but neither she nor her husband had made a success of their careers. Gustav had six brothers and sisters, two of whom, Ernst and Georg, also went on to be artists. Ernst was a talented painter whose career was cut short by his tragically early death, and Georg followed in his father's footsteps to become an engraver and designer. Both worked with Gustav in later years.

The Klimt family was not well-off, and when Gustav left school at fourteen, he joined the Vienna School of Arts and Crafts, hoping to develop his precocious talent for drawing in order to get a job as soon as possible, perhaps as an art teacher, and thus begin to contribute to the family's finances. In fact, once Gustav was launched on his career, he would support his family financially for his entire life, and give a home to his mother and two of his sisters.

The Vienna School of Arts and Crafts was a new institution when Klimt joined it, having only been founded in the early 1860s. It was attached to the Imperial Austrian Museum for Art, and both establishments were intended not only to display exhibits, but to promote the development of practical skills and knowledge. The education the school provided was traditional and workmanlike, even conservative, with an emphasis on discipline and perfection. Pupils studied perspective, worked on their copying, and examined historical sources.

Great stress was placed on accurate drawing and formal representations of classical models. This was an extremely thorough grounding in the basics of art, and was to stand Klimt in good stead. Although his art was later to break new ground, it is never less than technically perfect. He had received praise for his very fine draughtsmanship – indeed, his early drawings show an ability of genius. The young student had, however, not yet understood that there were artistic barriers to be breached, much less that he would himself breach them.

His brothers Ernst and Georg joined him at the School of Arts and Crafts over the next couple of years, and the creative talents of all three were recognized at once. Most of the students at the School, the Klimts and their friend Franz Matsch among them, contributed to the decorations for the pageant celebrating the silver wedding anniversary in 1879 of the Emperor Franz Josef and the Empress Elisabeth.

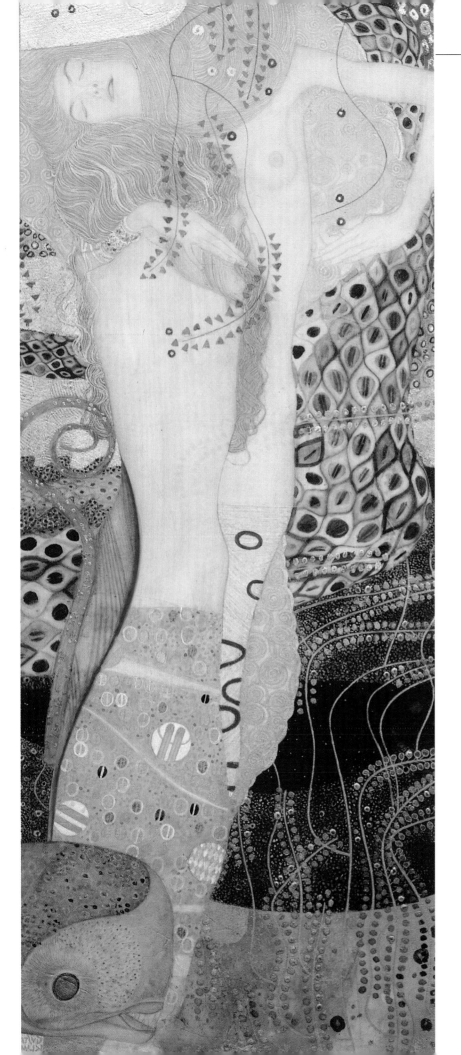

Water Snakes II (*Friends*), 1904-07
(Private collection). One of Klimt's
recurrent themes is water as the source
of all things; he regularly expounded its
links with womanhood. Here lithe
female bodies float in the water, their
hair and the eddies around them
spangled with bright gold, stars and
white flowers.

The decorations and festivities were designed by the painter Hans Makart, at that time the 'painter prince' of Vienna, and one of the most famous painters of Europe. Makart's vast tableaux represented sixteenth-century craftsmen's guilds, all dressed in historical costume and uniforms and accompanied by brass bands, and with their glamorous theatrical devices they were well received by a populace whose real preference was for artifice rather than reality.

Much of Makart's art was dedicated to enhancing Austria's historical reputation, and his huge canvases depict military victories (many of which never actually took place) and events of theatrical magnificence. His own life was also lived flamboyantly and removed reality. He often dressed in historical costume, and his home and studio resembled stage sets, filled with opulent props. Makart and his heady style were widely admired, and young Gustav Klimt was one of his acolytes, wanting nothing more than to follow in his footsteps. Indeed, the story has it that one day Klimt bribed Makart's servant to allow him into the artist's studio while he slept so that he could soak up the atmosphere undisturbed.

Gustav, his brother Ernst, and Franz Matsch together founded their own art studio, the Künstlercompagnie, and they began to be offered commissions. Their first was in 1879, when they undertook to enlarge the designs by one of their tutors for some of the windows of the new Votivkirche on the Ringstrasse. In Gustav's third year of studies he was given a grant from public funds, and this, together with the payment for other small commissions, meant that he was now able to help his struggling family.

On leaving the School Klimt strove to adhere to the historical style he had been taught, and which he admired so much in the work of Makart. Klimt, Ernst Klimt, and Matsch moved into premises of their own in 1883, and accepted commissions to decorate villas and theatres outside Vienna, in Carlsbad and Bucharest. They would of course have preferred to work closer to home, where they wanted to make their names, and were delighted to be commissioned by the City authorities to make a record of the old Burgtheater before it was demolished. Klimt's painting *Audience at the Old Burgtheater*, executed in 1888 and extremely well received, depicts the auditorium of the old theatre, filled with an audience consisting of accurate portraits of the most prominent of Viennese dignitaries and citizens.

Having a portrait in this picture reaffirmed to socialites that they were members of a cultural elite, and in celebrating this role for them Klimt made himself well known and well liked. His only difficulty was in choosing whom to include and whom to consign to obscurity by their exclusion.

In the same year, the three friends were commissioned to decorate parts of the newly completed Burgtheater. This was an extremely

Sonja Knips, 1898 (Austrian Gallery, Vienna). In her gauzy pink dress, Sonja Knips seems almost illuminated from within against the impenetrable dark of her background. She is half rising from her chair, and wears a serious and thoughtful expression.

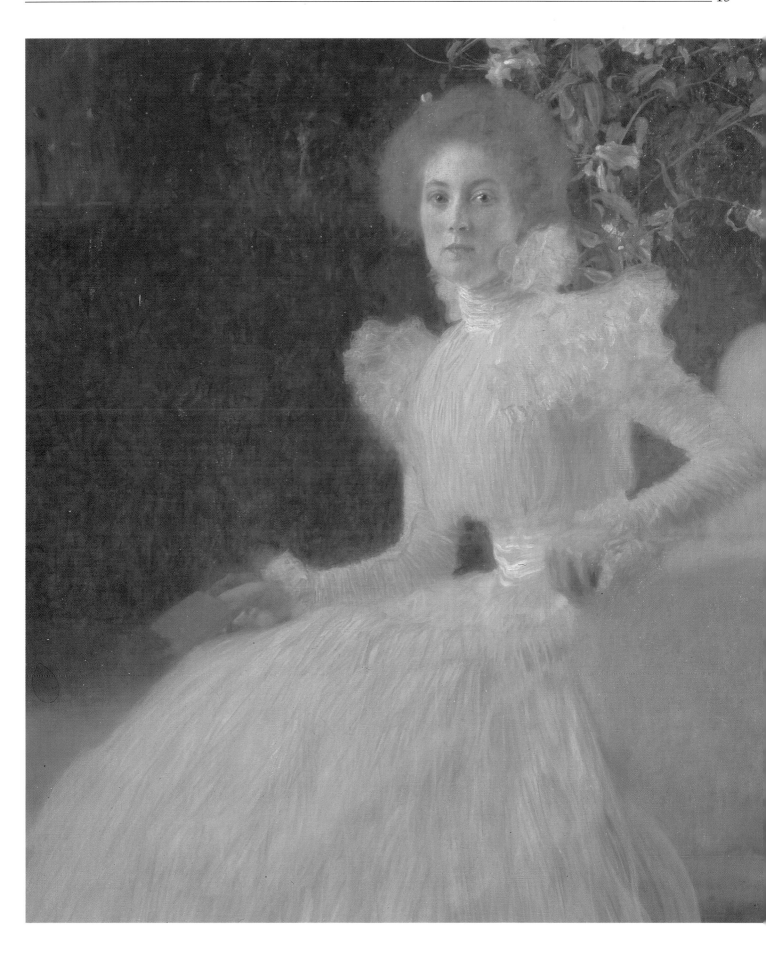

prestigious commission, especially as the work was being financed by the Emperor personally. The subject chosen for the paintings was the history of world theatre, and Klimt was assigned to produce a scene from a classical Greek drama, a scene from a medieval mystery play, and the death scene of Juliet from *Romeo and Juliet*. The latter contains the only self-portrait he ever painted. The work for the Burgtheater took over two years to complete and has a photographic quality which is explained in part by the fact that the artists did occasionally use photographs to help with their compositions. In 1893 the Emperor himself bestowed a major prize upon the artists.

The three young artists wanted nothing more than to be commissioned for work on some of the new Ringstrasse buildings. The middle classes were finding the confidence to commission works of art and buildings, and the huge programme of public building on the Ringstrasse provided opportunities for artistic commissions of all kinds.

They were overjoyed when, in 1890, they were asked to work on the decoration of the entrance hall and staircases of the Museum of Art History, a new building designed to house the Imperial art collection, which was being thrown open to the public for the first time. The commission came their way as a result of the premature death in 1884 of Hans Makart, who had been given the original commission, and they were asked to keep strictly to the theme devised by him, that of Imperial beneficence and patronage of the arts. The friends filled the spaces with designs borrowed from many periods, from the art of ancient Egypt to that of the Florentine *Cinquecento*. They undertook hours of meticulous research for their ideas, and Klimt in particular had no difficulty in producing several marvellously rich paintings, historically accurate in every detail.

He portrayed historical personifications set in backgrounds of ancient Egypt, Greece, and Italy; with decorations intended to show the burgeoning middle classes how cultural events of the classical past had come to a climax with their own era. The result is a riot of theatrical overabundance – and for Klimt a rapid and thorough education in the history of art and of the theatre. It was at this point that he began to understand the vast reservoir of architectural sources open to him, and he found he had no difficulty in absorbing as many forms and styles of ornament as he could find.

Girl from Tanagra, representing an aspect of Greek art, is his first depiction of woman as *femme fatale*. Her heavy-lidded, steady gaze is directed beyond the viewer as she coolly fingers a flower. She is a precursor of the intense *Judith* of later years. Here, too, Pallas Athene appears for the first time.

For the first time, Klimt's work shows the exceptional quality which was to set him apart from his Viennese contemporaries. The

Schloss Kammer on the Attersee III, 1910 (Austrian Gallery, Vienna). Klimt's third painting of the Schloss Kammer, is in even closer focus than the previous depictions. The trees at the water's edge, in full leaf, hide the castle which seems to be peeping out from behind them.

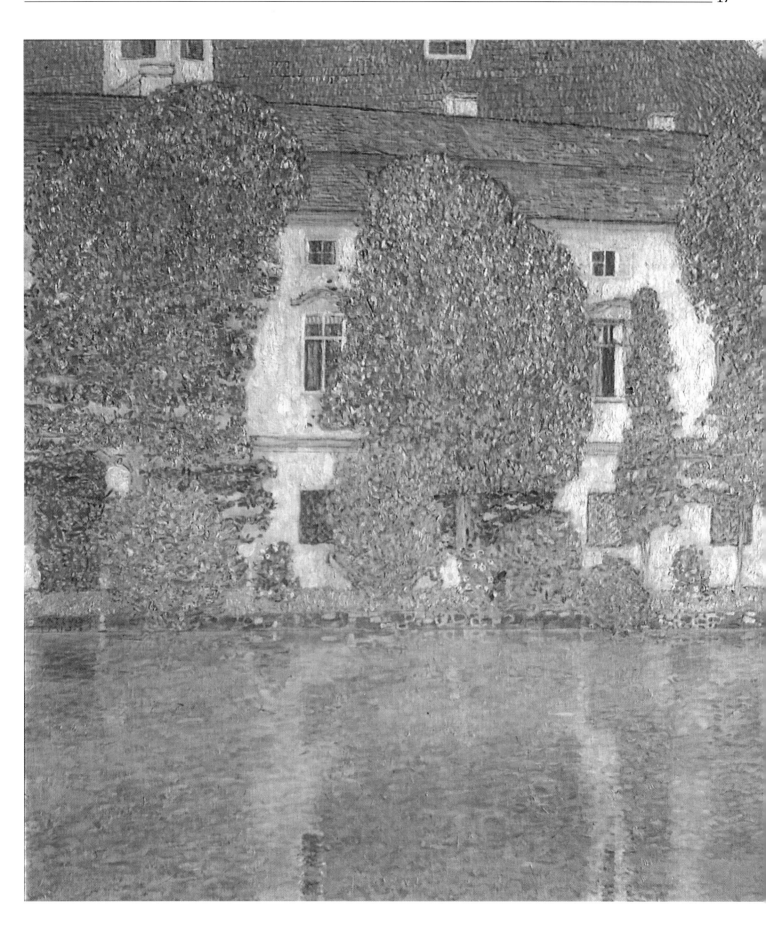

Mermaids, *c.* **1899** (Zentralsparkasse-Bank, Austria). Another Klimt painting in which water is used symbolically; here there is a direct link between women and water as there is in other works like *Water Snakes* and *Goldfish*.

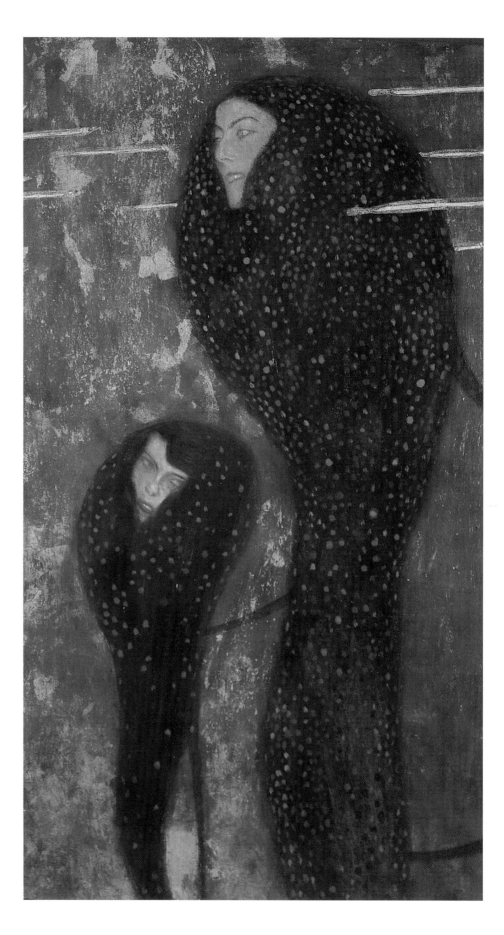

paintings have an aloof character, coupled with a directness – all in an absolute period style. It was obvious that here was a poetic artist with great promise.

While still at Art School in 1881 Klimt was asked by Martin Gerlach to submit samples of his work. A well-known publisher, Gerlach required paintings for a pattern-book of allegories and emblems. The book was to be in three parts, and was intended to provide a series of ideas and models for the use of artists depicting allegorical themes. In 1895 Klimt submitted two portfolios of delicate, classical works, among them *Love*. This allegorical work shows the first of many embraces which appear in Klimt's paintings. It also shows Klimt's early interest in framing his work with a broad border or frame, usually golden, in which exquisite flowers and foliage echo the fuller canvas of the painting itself. *Music I*, also submitted in 1895, shows a young girl plucking at a lute, surrounded by classical emblems such as a Greek theatrical mask and a sphinx. Here is Klimt's early use of gold, providing a richness and light that was missing from much of the work of his contemporaries.

The Künstlercompagnie was by now so successful that the trio moved to larger premises in the Josefstadt district of Vienna. Sadly, in 1892 both Gustav's brother Ernst and his father died, and Gustav shouldered the responsibility for his brother's young widow and daughter as well as for his mother and remaining siblings. The deaths of his father and brother must have hit Klimt hard, because certainly for the following four years he painted very little. During this time Matsch moved out of the studio and it soon became clear that Klimt's view of art had moved on. In attempting to push back the boundaries of allegorical painting he was to find that a man speaking a new language is not always understood.

In 1898 the industrialist Nicolas Dumba commissioned Matsch and Klimt to undertake not only the interior design but also the architectural work on three rooms in his grand new house on the Ringstrasse. This gave the artists a chance to put into practice their theories on the artistic use of space to create a unified whole. They were attempting to create an atmosphere congenial to the self-image of their client. Klimt painted the wall decorations for the Music Room, and also two supra-porte paintings, *Music II* and *Schubert at the Piano*. These paintings are important since they mark the transition of Klimt's work from his early, academic style to his later Secessionist work.

Although technically still working with a historical theme, Klimt no longer adhered strictly to historical accuracy. The figures in *Schubert* wear contemporary dress, and despite the realistic depiction of Schubert's face, the painting has an almost Impressionist quality, with its unexpected light sources and dabbing brushstrokes. The girl's face

in *Music II* shows the calm, knowing look so often seen in his later portraits, and the abstract background foreshadows the highly ornamented portraits still to come.

Both Klimt and Matsch were members of the Viennese Co-operative Society of Austrian Artists, a powerful organization which embodied all that was traditional and inward-looking in Viennese art. The Cooperative arranged commissions for its members, staged exhibitions, provided a lead and showcase for younger artists. Klimt, essentially a shy and introverted man, came to feel strongly that the Society was not encouraging modern and progressive influences, or fostering inspirations from abroad, that it was provincial in outlook and stifling original work. Word had certainly reached Vienna of developments taking place in other countries, particularly in France with the strikingly original work of Manet, Degas, or Renoir; but none was to be seen in Austria.

Klimt entered the public arena rather against his own will as a champion of the 'modern movement' in Vienna. He was not happy to publish his views in his own words; he was never comfortable with the written word, preferring to express himself through his paintings.

In 1897 he and eight other members resigned from the Society and set up a Secession movement, calling themselves at first the Association of Austrian Artists. In this they were encouraged and shown the way by the Munich Secession of 1892, when a similar group of young artists had broken away from their local conservative establishment artists' association. The Vienna Secession's objectives were summarized in the first issue (Winter 1988) of their magazine, *Ver Sacrum* (Sacred Spring):

> *1. The Association of Austrian Artists has made it their task to promote purely artistic interests, especially the raising of the level of artistic sensitivity in Austria.*
> *2. They aim to achieve this by uniting Austrian artists both in Austria and abroad, by seeking fruitful contacts with leading foreign artists ... promoting Austrian art at exhibitions abroad, and by making use of the most significant artistic achievements of foreign countries both to stimulate art in our own country and to educate the Austrian public with regard to the general development of art.*

The Vienna Secessionists elected Gustav Klimt as their first president, and set about building themselves their own premises to house their exhibitions. The building was designed by Josef Olbrich with help from Josef Hoffman, one of Klimt's closest friends and a man hugely influential in the field of design. At the turn of the century, Hoffman was working in a style very close to *art nouveau*, but around 1900 he fell under the spell of the English designers William Morris

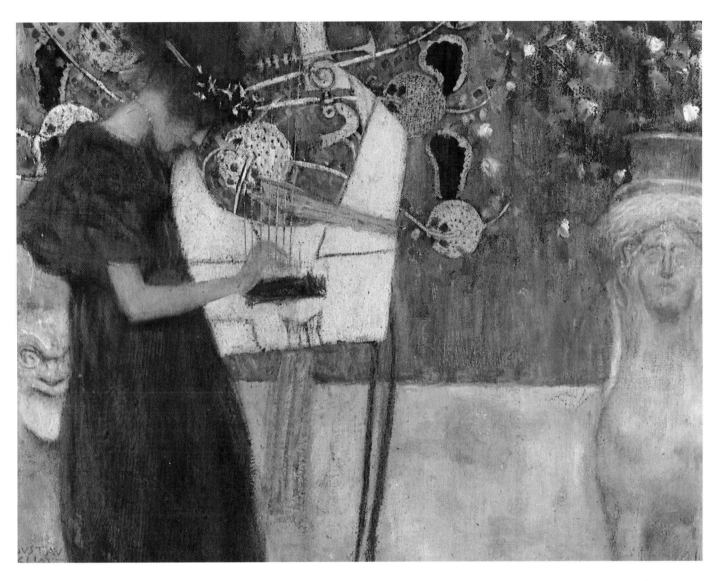

Music I, 1895 (Neue Pinakothek, Munich). Commissioned for a work of allegories and emblems, this classically influenced work is an example of Klimt's early use of gold to add richness and to create a lavishly beautiful painting.

and John Ruskin, and also the strikingly original 'Glasgow Boy', Charles Rennie Mackintosh. Hoffman's work is austere and elegant, and the Secession Building was the perfect space for the new group to show their unconventional works.

It is interesting that the authorities very quickly came to support the Secession, not only financially but also in other ways. As early as 1900 it was the Secession rather than the Society of Artists which was being asked to represent Austria in an official capacity. Unlike the authorities in other European capitals, the city of Vienna supported cultural advances, even founding a Museum of Modern Art in 1903 which was to be devoted to the work of Austrian artists. They hoped perhaps that in promoting an Austrian identity and culture, the fragmented peoples of that multi-national empire would be drawn together for greater political security. Perhaps they hoped also that a concentration of cultural concepts would distract the minds of the people from political disquiet and activism.

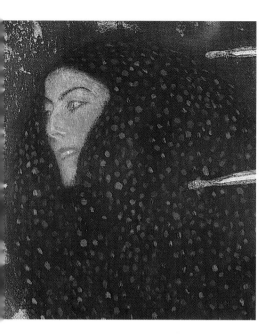

Mermaids, c. 1899 (detail)
(Zentralsparkasse-Bank, Vienna). Klimt
used the face of Rose von Rosthorn-
Friedmann, whose portrait he painted
in about 1901, for this enigmatic picture
depicting muffled water nymphs in a
mottled, gold milieu.

The Secession was an extremely energetic young organization. Its members immediately set about inviting artists such as Whistler, Rodin, John Singer Sargent, and Fernand Khnopff to their first exhibition, which they held in rented premises in 1898. Klimt produced an impressive poster for the first exhibition showing Theseus and the Minotaur; it had to be redrawn with the inclusion of a strategically placed tree as the authorities felt that Theseus's nudity was unacceptable.

The uproar over this ensured a good supply of publicity for the exhibition. The poster's allegorical theme represents the victory of pure reason over the dark powers of folly, and was intended to focus on the Secession's struggle against older forces.

The second exhibition was also held in 1898, this time in the Secession's own building, paid for mainly by the proceeds of the first exhibition and completed in record time. The motto carved into the stone above the doorway to the building read: '*Der Zeit Ihre Kunst, Der Kunst Ihre Freiheit*' – 'To our time its art, and to art its freedom'.

The exhibitions were intended to bring to Vienna fresh influences from foreign artists, and in this respect they were very successful. Provincial Vienna was entranced. The public was aware that for them the exhibitions represented nothing less than a revolution, even though perhaps in world terms it was not so important. Still, the Emperor himself visited the exhibition, followed by more than 55,000 visitors, and nearly half of the exhibits were sold. Klimt showed seven paintings at the second exhibition, works which point to the mature painter he was to become. Among them was *Pallas Athene*, a painting in the classical mould with an integral frame, designed by Gustav and made in embossed copper by his brother Georg, one of the last of Klimt's works to use such a device.

The first of his famous portraits of society ladies of Vienna, a study of Sonja Knips, was also exhibited at the November 1898 show. In this early work his subject was placed in a garden, seated: later it became characteristic of Klimt's portraits that the subject stood facing forward, immobile, challenging the space in which they found themselves. Sonja Knips seems poised for movement; her expression is wary. Her soft pink dress and the sensuous soft focus of the painting are reminiscent of Whistler's work.

From the beginning *Ver Sacrum*, the regularly published magazine of the Secession, was intended as a mouthpiece for the views of the fledgling organization, and to publicize forthcoming artistic events. Published to the highest of production standards, the issues quickly became collectors' items. The writer and art critic Hermann Bahr helped to edit the magazine, and the writing was of a consistently good quality. Contributors included Rainer Maria Rilke and Charles Algernon Swinburne. Klimt produced several covers for the magazine, and for a short time was on the editorial board.

Klimt had begun painting his early landscapes by 1897. It was the countryside round the Attersee which inspired the best of these, and *Orchards and Farmhouse with Climbing Rose* was his first. At the time of his death he had completed fifty-four. He painted his landscapes mainly during the summer months, probably for relaxation, and many were completed in the open air, rather than working in the studio from preliminary sketches.

About this time, he began his series of portraits of fashionable, wealthy society matrons. He had painted portraits before, but those of Sonja Knips in 1898 and Serena Lederer in 1899 began the chain of paintings which ran through the rest of Klimt's life. Serena Lederer was a great friend of Klimt, and her wealthy husband Auguste built up a large collection of Klimt's paintings. Klimt painted Frau Lederer in diaphanous white on white, only her dark hair and strong features standing out from the painting. Klimt worked slowly, but he was kept busy with private commissions, and was able to charge substantial fees for his portraits. His patrons were drawn from the ranks of the prosperous industrialists who had newly made their fortunes in commerce, and who together with their wives had developed a discriminating taste for the modern style of the Secessionists. Many of their names are known to us as the husbands of the beautiful women in Klimt's portraits: Ferdinand Bloch, Adele Bloch-Bauer's husband, was a merchant banker with interests in sugar and printing; Karl Wittgenstein was a steel magnate and a patron of the arts (he was a friend of Brahms, of Mahler, and of Pablo Casals; his son was the philosopher Ludwig Wittgenstein); and Otto Primavesi.

In 1900, everything changed. Klimt and Franz Matsch had been asked, in 1891, to decorate the ceiling of the Great Hall of the University of Vienna, a commission which was the last they were to undertake together, and which was to mark a dramatic turning-point in Klimt's career.

CHAPTER 2

Artist Alone:
1900 to 1918

The Ministry of Culture commission to paint part of the decorations for the ceiling of the Great Hall at Vienna University was to comprise four paintings symbolizing the main faculties of the University, Theology, Philosophy, Jurisprudence, and Medicine.

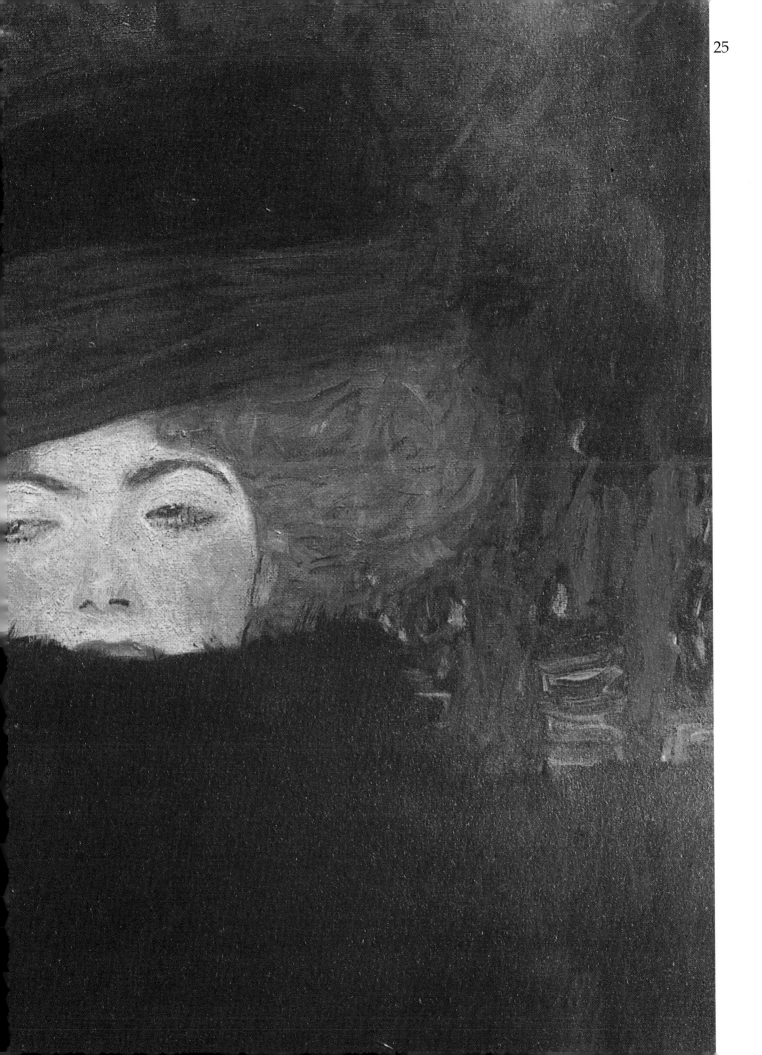

Overleaf:
Lady with Hat and Feather Boa, 1909
(Austrian Gallery, Vienna). Klimt
painted several portraits of women
wearing large hats and voluminous
outer garments, but whose identities
unknown to us. This redhead may be
the same model as in the 1910 picture,
The Black Feather Hat.

Klimt was to be responsible for three of the four faculty paintings
while Matsch would undertake Theology and a central panel
representing the triumph of education over ignorance. Even
though his reputation stood at a high point after the success of
Audience at the Old Burgtheater and his work at the Museum of Art
History, Klimt seemed nervous and work continued slowly. *Philosophy*
was still not finished in 1900; however, it had been announced for
inclusion in the Secession Exhibition for that year, and Klimt agreed to
hang it, only to find himself and his painting at the centre of a huge
controversy.

The painting is large and complex, and notes were printed in the
exhibition catalogue to help the public understand it. Plainly an
allegory, it seemed incomprehensible to its viewers, who were
bemused; although the art-loving public of Vienna was highly literate
with what they knew, they did not understand the new vocabulary
Klimt had used.

Klimt found himself at a crucial point in his career. He realized
that he could no longer paint to order, and that his artistic develop-
ment was pulling him in a different direction from that required to be
an obedient interpreter of others' ideas.

Even though Klimt sent *Philosophy* to the World Fair at Paris that
year, where it won a Gold Medal, the scandal continued to rage. When
in 1901 the second of the paintings, *Medicine*, was exhibited at the
Secession, it only added fuel to the fire. *Medicine* proved to be just as
incomprehensible as *Philosophy*. It appeared to have been painted in a
visual language quite unlike that of any allegory with which Vienna
was acquainted; but even those who thought they understood it found
the message profoundly pessimistic and disturbing. Klimt showed his
third painting, *Jurisprudence*, in 1903, and accusations of pornography
swelled the controversy. Although the Ministry did not cancel the com-
mission they decided to install the paintings in a museum rather than
in the University. When they also refused to lend the paintings to the
1904 World Fair in St Louis, Klimt, furious and misunderstood, refused
to finish the paintings or to hand them over in their unfinished state.
He returned the advance payments, with financial help from his most
important patron, the distiller Auguste Lederer.

The Secession hosted more than one exhibition each year. In 1902
they held an important and innovative exhibition for which the
interior of the building was totally refurbished. Klimt contributed a
seven-part frieze to accompany not only the statue but also a special
orchestration by Gustav Mahler of the fourth movement of
Beethoven's *Ninth Symphony*, which was performed at the opening of
the exhibition by the Vienna opera chorus. Again, notes in the exhibi-
tion catalogue attempted, not entirely successfully, to cast light on
Klimt's symbolism.

Opposite:
**The Golden Knight (Life is a Struggle),
1903** (Private collection). This is a rare
instance of an animal appearing in
Klimt's work – a magnificent warhorse
accoutred in gold and prancing in a
flower-filled meadow. A knight in
stylized golden armour and a heraldic
helmet rides stiffly. A starry
background contributes to the mosaic
atmosphere. His counterpart is the
golden knight in the *Beethoven Frieze.*

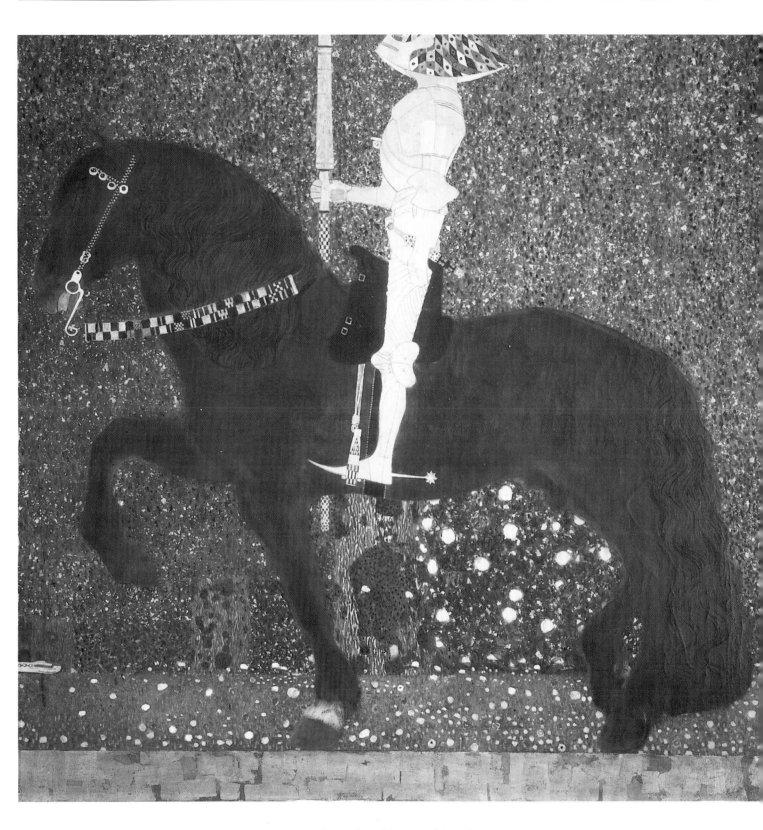

The Secession movement was an association of artists working in all fields, from easel painting to architecture, from typography to stage design, from sculpture to furniture design. These applied arts needed a showcase, and accordingly in 1903 Josef Hoffman and Koloman Moser

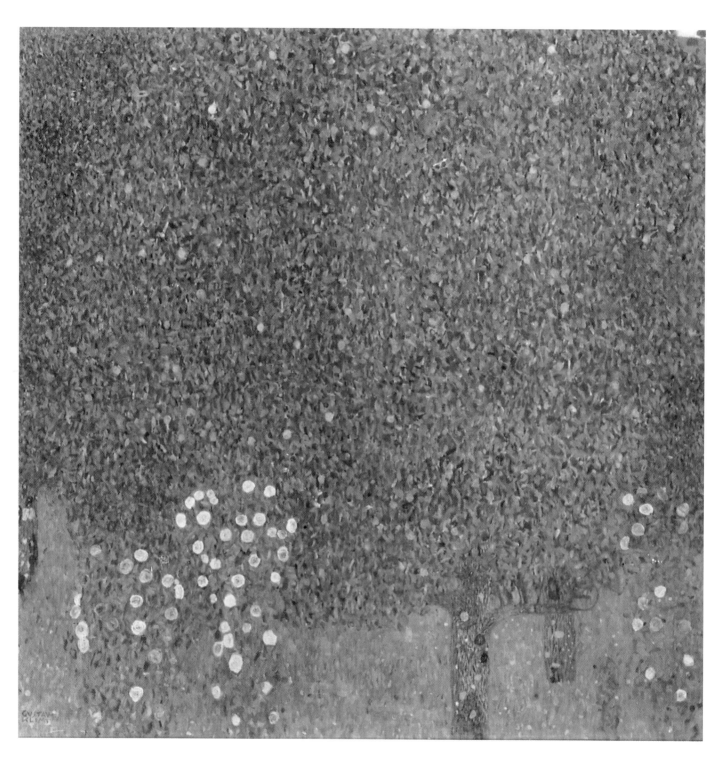

Rose Bushes under Trees, *c.* 1905
(Gallery Welz, Salzburg). The trees have
a dense, mosaic-like quality,
impenetrably filling the space available
to them. Beneath them rose bushes
sparkle, irresistible counterpoints to the
compact mass of the trees.

set up the Wiener Werkstätte, the Vienna Workshop, not only to sell the
designs they made but also to train others in the techniques needed to
make them. One of the inspirations for the Werkstätte was the English
Arts and Crafts Movement; another was the work of Charles Rennie
Mackintosh. Hoffman and Moser were both members of the Secession
movement and had already brought Mackintosh's work and that of
the Arts and Crafts Movement to exhibitions in Vienna.

The Wiener Werkstätte set itself up in its own premises, and cultivated an atmosphere in which it was possible for craftsmen working in any discipline to flourish. Designers worked on fabrics, furniture, and glassware to complement the work of the architects; artisans in the workshops carried out the physical manufacture. The workshop answered a need among the younger members of Vienna's high society, who wanted a style they could call their own, one that was less stifling than their parents'. These avant-garde socialites commissioned Hoffmann to design and outfit their houses; clad in Werkstätte jewellery they enjoyed evenings at the Cabaret Fledermaus, the nightclub created by the Werkstätte in 1907.

Many of the young society matrons whose portraits Klimt painted were patrons of the workshop and liked the idea of obtaining, in their paintings, a lasting monument to their chic. Klimt had close links with the workshop. He designed fabric and furniture for them, and also assisted with the administration.

The contradiction at the heart of the Werkstätte, however, was never resolved, just as it had not been in William Morris's British Arts and Crafts Movement. If all aspects of life were to be harmonized and made beautiful through art, it was clear that only the well-off would be able to afford to put the theory into practice, and that those who needed it most were least likely to achieve it. So paradoxically the very beauty with which the rich congratulated themselves on having the good taste to surround themselves also provided them with a shield which allowed them to forget the existence of anything ugly or disturbing beyond it. *A l'outrance,* this permitted the middle classes to ignore the political crises at the start of the twentieth century – the Boer War, the Russo-Japanese War, the Balkan question which inexorably led to the First World War and the destruction of their world.

One of the Wiener Werkstätte's early commissions was to fit out the premises of the fashion house belonging to Emilie and Helena Flöge. Helena was young Ernst Klimt's widow, and Emilie was to become Gustav Klimt's greatest friend, though never his wife. The Flöge fashion house was fitted out by the Werkstätte in a livery of black and white, with cool, simple lines, and the sisters often worked with Werkstätte-designed fabric. The fashion house was a large employer, with at one time as many as eighty seamstresses and cutters working there, as well as a model and various accounts staff. The Flöge sisters lived comfortably in an apartment connected to the salon, where they were looked after by a housekeeper, a cook, and a chauffeur. Catering only to the wealthy members of society, the salon flourished, and indeed it was not until the German invasion of Austria at the onset of the Second World War that it ceased trading.

Klimt himself was interested in fashion, and designed several dresses for the Flöge fashion house as well as encouraging Emilie in

her designs for the Reform Movement. This movement was turning its back on the corseted, restricting garments worn by respectable matrons at the time, to producie loose robes which hung from the shoulders, made up out of fabric in bold, geometric designs, often from the workshops of the Wiener Werkstätte. The Flöge sisters also catered at their salon for those who preferred established fashions, but they felt strongly that to be elegant or formal it was not necessary to sacrifice comfort or practicality.

Vienna was slow to take up the new shapes arriving from America and England, but gradually the traditional hour-glass figure came to be regarded as old-fashioned. As the salon became established, so most of the gowns and accessories were designed by the Flöge sisters themselves. Gone were the social conventions of the bourgeoisie for the Reformers; they advocated a free way of life very similar to that of the hippies in the 1960s. Klimt and Emilie between them designed a collection in 1906 and Klimt photographed Emilie modelling the designs. His photographs, taken out of doors in a sunny garden, are striking. They show a painterly contrast between the abundant foliage and flowers of the backgrounds, and the stark shapes of the new designs.

In 1905 the Secession was riven by a disagreement between its members. The disagreement seems to have been on the fundamental point of the purpose of the Secession, and on the gathering commercialization of some of the members. Those who were principally painters felt that the Wiener Werkstätte, with its emphasis on applied arts and on the commercial exploitation of their work, had too close an association with the Secession, to the detriment of traditional painting. However, at the time, commentators found it difficult to discern any real differences between the opposing camps, and it could be that it was simply a case of a forward momentum being impossible to maintain. Finally Klimt and his circle, more versatile in their approach to the decorative arts, broke away, repeating history with this second Secession. The decision to part company cannot have been an easy one, and the break-up, which took place amid rather public wrangling, shocked Vienna.

With no premises of their own now in which to show their work, the so-called Klimt Group borrowed rooms for their exhibitions until some land for a temporary venue was put at their disposal. Their 1908 show, designed to commemorate the sixtieth anniversary of Emperor Franz-Josef's accession to the throne, was devoted to Austrian artists, among them the young Oskar Kokoschka. Josef Hoffman designed a small complex, and here two exhibitions, both called Kunstschau Wien, took place. Hoffman's sets were intended to demonstrate the unity and artistic integrity of all the decorative arts, and the comprehensiveness of beauty. To achieve this, the complex was more than just

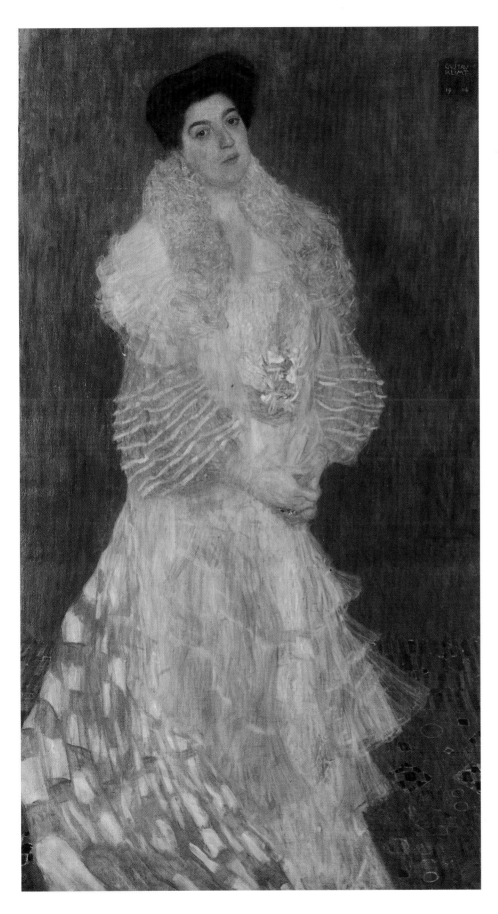

Hermine Gallia, 1904 (National Gallery, London). This portrait is considerably less adventurous than that of Emilie Flöge, painted in 1903. Hermine Gallia stands on a conventionally patterned carpet against a plain background, and although she is wearing a heavily flounced dress its pattern does not dominate the picture.

rooms in which paintings were hung; it was a complete mise-en-scène, with roomsets, a church, and even a cemetery. The Kunstschau borrowed the Secession's motto of 'To our time its art, and to art its freedom', in this way signalling its wish to be viewed as the clear heir to the Secession.

Among the sixteen of Klimt's works shown at the 1908 exhibition was his famous *Kiss*, immediately bought by the Austrian Government; it was recognized instantly as being a work of extraordinary power, and is to this day probably Klimt's most widely reproduced and best-loved painting. Klimt gave the opening address at this show, and his speech was also reproduced in the programme notes. In it, he is emphatic about the need for art to inform every area of human life, and he cites William Morris's famous aphorism that one should surround oneself only with things that one knows to be useful or believes to be beautiful.

Although the ideas to which he gave voice, those of the comprehensiveness of art and the need for beauty, were not original, a powerful sub-text of his address was the link between the cultural unity of the Habsburg Empire and that of its personification in the Emperor. The State had provided financial support for the Secession in its early days and had continued to offer commissions for public jobs to Secession members, and the ensuing patriotism of Klimt and his group was never in doubt.

The 1908 show also showed work by such artistic giants as Van Gogh, Gauguin, Munch and Matisse. Klimt hung eight paintings and seven drawings, including *Judith II* and *Hope*. The show included work by students of the Art School, among them Egon Schiele, whose disturbing and psychologically intense portraits and densely worked allegories were soon to make Klimt's work seem rather old-fashioned.

Klimt was always generous with younger artists, although he was only forty-seven when he said, 'The young ones don't understand me any more. They're going somewhere else.' He knew that even though he had been instrumental in opening the door to the wind of change which blew through the Viennese art establishment at the turn of the century, he himself was now being left behind. He understood that change was healthy within an artistic environment, and that to nurture talent wherever it could be found was a duty of those who had managed to establish themselves, even if they found the new art hard to understand.

In 1904 Klimt was commissioned by the wealthy Belgian industrialist Adolphe Stoclet to undertake the decorations in the dining room of his new house in Brussels, which had been designed down to the last detail by Josef Hoffman, and built by a Wiener Werkstätte team of craftsmen. This most luxurious of buildings took seven years

Girl Friends, 1916-17 (destroyed by fire 1945). Two girls stand together, one naked and one robed in vivid red. They are calm, immersed in their own world and with interest only in each other. Their mysterious, exclusive universe contains no hint of reality.

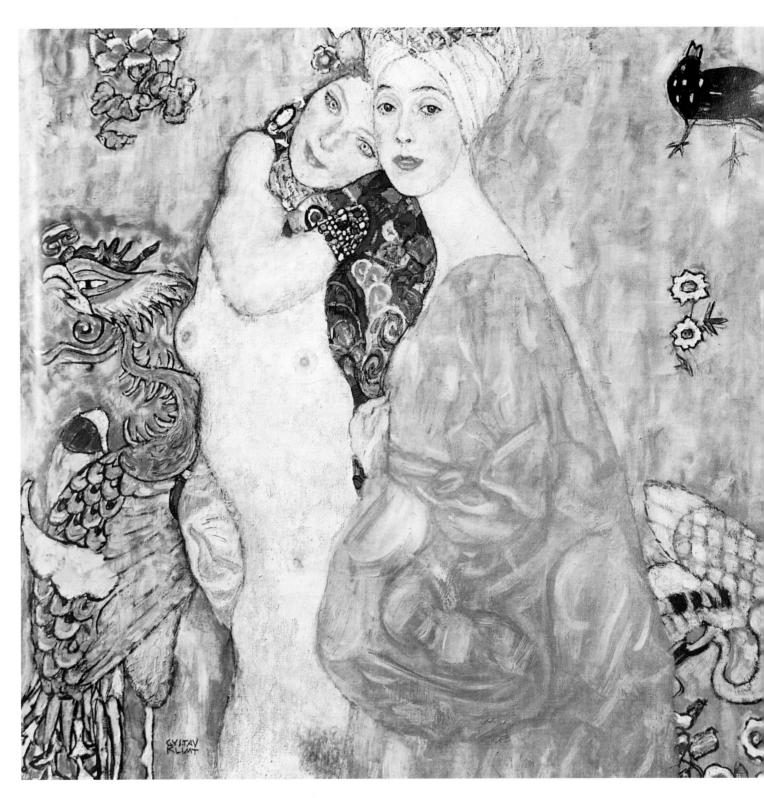

to complete. No one knows how much the house cost to build; Stoclet had inherited the family fortune, made in coal, and was in a position to stint on nothing.

Hoffman had been longing to have the opportunity to design a complete, integrated house, and he personally designed almost every

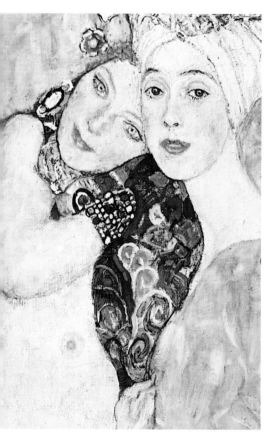

Girl Friends, 1916-17 (detail)
This is an exotic painting and one in which Klimt has been much more generous with his brushstrokes. The overt sensuality caused an uproar.

detail, down to the cutlery and the door handles, untrammelled as he was by considerations of cost or cultural content. No detail was too small to be part of the overall plan. Even the carpets were specially woven. The Belgian artists Fernand Khnopff and Georges Minne were also involved in the decorations, but all the other artists were Viennese, and the finished house is an eloquent testimonial to the Viennese Secession style.

The young artists Oskar Kokoschka and Egon Schiele, then students at the Academy, contributed designs – Kokoschka designed six needlework panels and Schiele a stained glass window. In the end, however, Stoclet rejected their ideas and the commission went to other artists. The drawback to this kind of all-embracing design were immediately clear to some. The house and all its contents were a tribute to the taste of the designer, and allowed no room for the personal, changing tastes of the owners or for relaxation. Nothing could be removed or added; even the clothes being worn had to be in keeping. It must have been more like living in a museum than in a comfortable home.

Klimt designed an elaborate collage and mosaic for the dining room, a gracefully stylized pattern of golden tendrils on three walls, containing an embracing couple and a single figure only barely discernible behind a mass of circles and colour. The work aroused a great deal of interest in Vienna, still despite everything a cultural backwater where even the innovative art of Picasso, or of the German Futurists, was not making a great impression. Klimt's work was still being produced in what amounted to a vacuum. The Viennese authorities wanted Klimt to display the Stoclet Friezes in Vienna, but, still burning from his treatment over the University paintings, he refused.

Klimt lived what appeared to be an ordinary life, sharing a home with his mother and two of his sisters, but he was also a highly sexual man and was deeply interested in women, both in general and in particular. Many of his paintings deliver a powerful erotic charge, and he made several sketches of women in all stages of sexual abandon. Klimt did not release these drawings during his lifetime, yet it is almost certain that his friends knew his lifestyle was not as conventional and strait-laced as it seemed. He seldom drew or even painted men, and when he did so it was generally in relation to women.

His subject is not only the female nude, however, and nor is his work ever prurient. His most abiding interest was in womanhood, which he dealt with in several different ways, from straightforward portraiture to many different allegorical treatments. His most powerful work represents women as dominant and compelling, as highly sexual creatures. Yet many of his paintings show women who appear to be completely passive in the face of physical pleasure.

He slept with several of his models, and it is likely that Adele Bloch-Bauer, whose portrait he painted twice and who was his model for *Judith and Holofernes* and *Judith II*, was his mistress. She was the wife of the banker and sugar magnate Ferdinand Bloch, who was a keen collector of Klimt's work, but there is no record that Bloch knew of the entanglement. Klimt pursued, but never caught, the young Alma Schindler, later to be the wife of Gustav Mahler. He fathered several illegitimate children, four of whose legal claims on his estate were upheld at his death. He had two sons with Mizzi Zimmermann, who modelled for him frequently and can be identified as the young girl illuminated by glowing candlelight in the 1899 painting *Schubert at the Piano*. When she became pregnant, Klimt used her as his model for *Hope I*, although he altered the face.

His relationship with Emilie Flöge is of a different nature. He did not exploit her for his art or for his pleasure; he took her seriously and respected her. All his adult life he spent the summers with her and her family at Lake Attersee at Salzkammergut. She was Klimt's closest friend, yet they never married, nor seemed to wish to do so, and their relationship was probably platonic. She and her sister Helena were successful in their fashion house business, and Emilie travelled often to London and Paris to purchase fabric and to attend fashion shows, bringing home to Vienna styles from such chic houses as Chanel and Rodier which the sisters made up for their clients alongside their home-grown Reform Movement garments.

Emilie was an independent career woman with a fashion salon to run and a living to earn, and she was probably as reluctant to forfeit her freedom as Klimt was. In an unconventional way, they did share a life; and it was Emilie whom Klimt sent for on his deathbed.

Hundreds of the postcards Klimt wrote to Emilie over the years have survived. These are not overtly affectionate in tone, yet in their very familiarity they hint at a deep intimacy. Although he was not comfortable with the written word, Klimt sometimes sent as many as four postcards a day to Emilie, and the contents assume that Emilie was completely au fait with every aspect of Klimt's life as probably no one else was.

Klimt used Emilie as his model four times. The first time was in 1891, when Emilie was seventeen years old, and is one of his earliest portraits. It is a charming but not striking work, a portrait in profile of a young girl wearing a virginal white dress. The painting has a beautiful golden integral frame decorated with foliage in a Japanese style. The portrait of 1902 was quite different. It depicts Emilie in a new style. Her face, hands, and the top of her chest are all that can be seen of her body. There is no clearly defined floor or background, only swathes of colour to suggest them, and yet Emilie is standing in a challenging pose, with her hand on her hip and her chin raised resolutely. Her hair is no

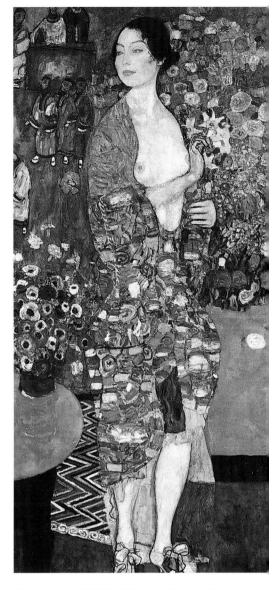

The Dancer, 1916-18 (Private collection) This highly decorative work started life as a portrait of Ria Munk, who was not happy with it. Klimt reworked it, and called it *The Dancer*.

The Dancer, 1916-18 (detail)
(Private Collection) Although more of the subject's form than usual is visible in Klimt's portraits, it is still subsumed by the brilliant coloration of the floral and Oriental background.

longer modestly set in a neat chignon, but forms a cloud of curls round her head. Her garment is a loose, soft Reform Movement robe, and a scarf billows up to form a halo round her head. Emilie herself did not like the painting, and Klimt sold it in 1908.

In addition, Emilie appears in the painting called *The Clown on the Improvised Stage at Rothenburg*, painted in 1893. This subject had been painted on the ceiling of the Burgtheater by Ernst Klimt, and an easel copy had also been commissioned. Ernst died before he could complete it, and Klimt took over the work. He made some alterations, among them the addition of Emilie and her sister, Klimt's own sisters, and Emilie's mother. Klimt also made a study for the painting which shows Emilie in the same costume and pose, standing in a walled garden framed with flowers and foliage. This picture and the early portrait of Sonja Knips are the only portraits by Klimt which contain paintings of fresh flowers or shrubs of any kind.

At the height of his fame, Klimt was an energetic, powerful-looking man, dark-avised and bearded. He looks a practical man, with his square face and humorous eyes. Indeed, despite a tendency to hypochondria he was in robust good health all his life, taking long walks, exercising with Indian clubs, and playing a regular game of skittles with his friends. He was unpretentious and shy, and continually maintained that he was not essentially an interesting man. He would not write a letter if he could possibly help it, and would often fail to read letters written to him.

Many photographs exist of him wearing the comfortable, loose-fitting smocks in which he liked to work. He was never happier than when at home in Vienna, or spending the summer months at the Attersee with Emilie. He liked his life to keep to a routine and, rather oddly for a man so important to the changing face of art in Vienna, was suspicious of new things in his own life. He began each day with a walk to his favourite café, the Café Tivoli, for breakfast, accompanied by his great friend the photographer Max Nähr, followed by a ride to his studio in the *Josefstädterstrasse*. There the spartan interior contrasted with the wild, rich garden filled with flowers and the families of cats to which he was devoted.

He liked to spend his evenings at a bar or a club with his friends, where he always ate with good appetite, and then finished his day with his mother and sisters. He owned many Chinese paintings and Japanese woodblock prints, as well as a collection of Oriental fabrics which were to provide him with inspiration for his later portraits. Indeed, his interest in Oriental art led him to arrange an entire exhibition of Japanese art at the Secession in 1900.

Klimt was not a keen traveller, spoke no foreign languages and was unsure of himself in unfamiliar situations. He went to Italy in 1897 with his friend Carl Moll, and in 1903 returned to visit Venice, Florence,

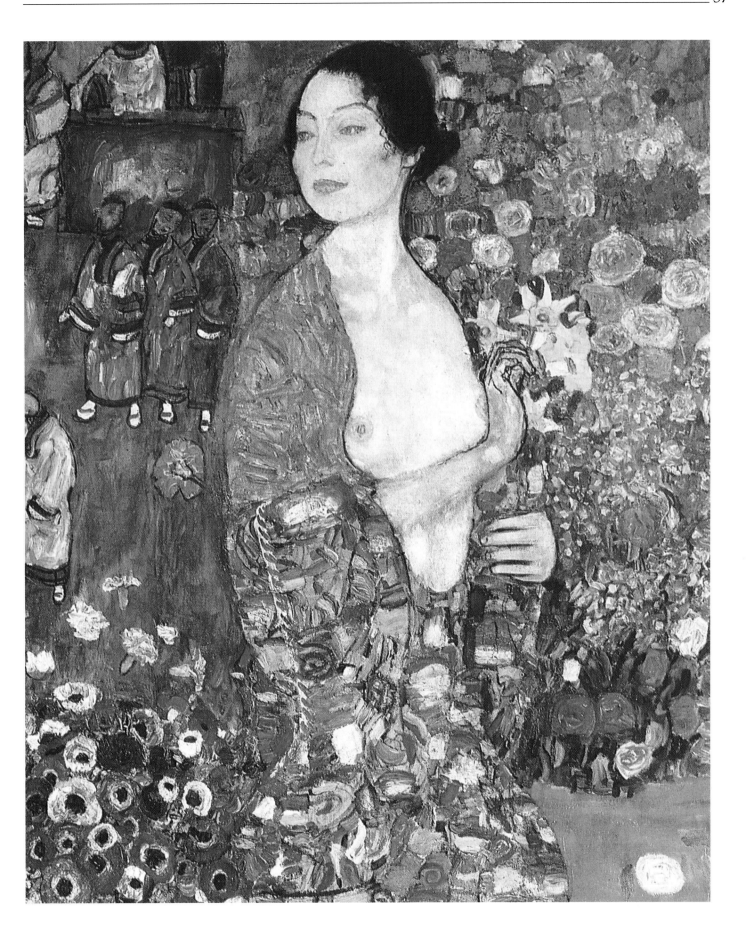

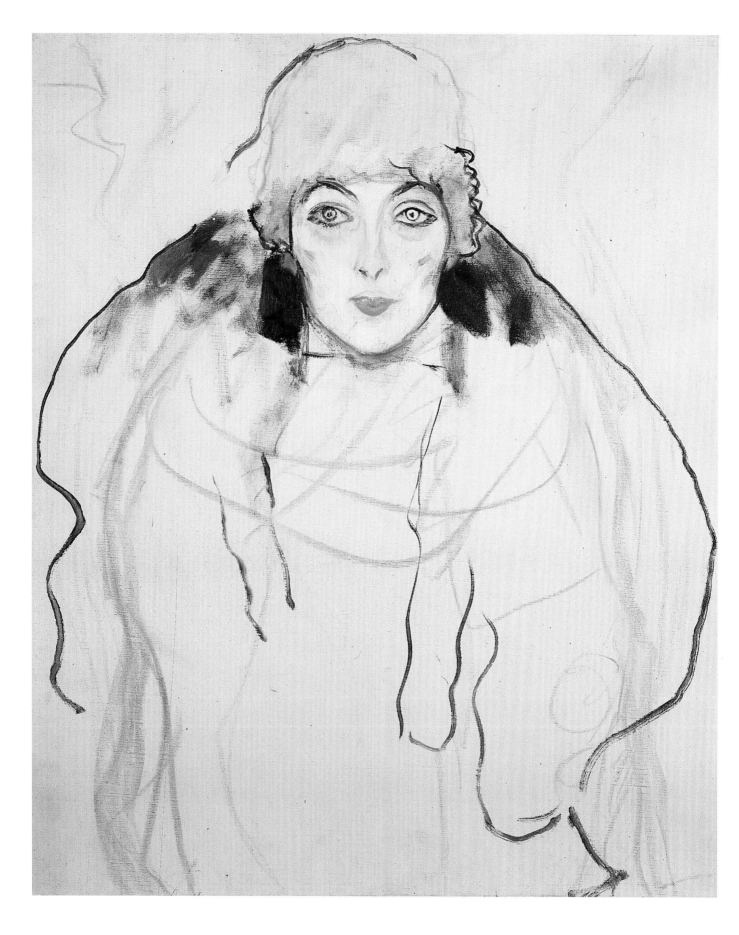

and Ravenna. He made one more trip to Italy, in 1913, when he painted some views on Lake Garda. He also went on short business trips to Munich and Berlin, and of course went to Brussels to work on the Stoclet Friezes. Lastly, he made brief visits to London, to Paris, and to Spain, again with Moll, where he saw El Greco's paintings. Yet this man, happiest in his own environment and never having studied the great art galleries of the world, was capable of the most sensitive, extravagant and subtle of paintings.

The outbreak of the First World War seems not to have disturbed Klimt's life and routine. He continued to follow his familiar practice, walking in the city, visiting the Attersee in the summer, working at portraits. The events convulsing the world were not reflected in the paintings on Klimt's easels: except possibly in *Death and Life*, which Klimt painted in 1908 and revised in 1915 overpainting the gold background with dark blue. Vienna itself, swollen with refugees, groaned under the threat of starvation; fuel was scarce; disease was rife. Were our only source to be Klimt, we would know nothing of this. His inner life remained serene and untroubled. The greatest upheaval for Klimt in these years was the death of his mother in 1915. He had taken on complete responsibility for her while still a young man, and she had remained a major influence on him all his life.

In early 1918 he suffered a stroke. Less than a month later he caught pneumonia – or it may have been influenza, which was ravaging all Europe in the closing months of the War. He died on 6 February and never had to take his place in a world which he would not have recognized.

Woman's Head, 1917-18 (unfinished) (Wolfgang-Gurlitt Museum, New Gallery of the City of Linz). One of the many pictures left unfinished at Klimt's death. We do not know the subject's name, and it may be that the picture was to become one of Klimt's late allegories.

CHAPTER 3

Drawings, Landscapes and Portraits

Klimt made many pencil sketches for his formal paintings, either portraits or allegories, and these preliminary drawings survive to tell us a great deal about the evolution of the finished work. But at the same time, he was making finished drawings in pencil and crayon, nearly always of women.

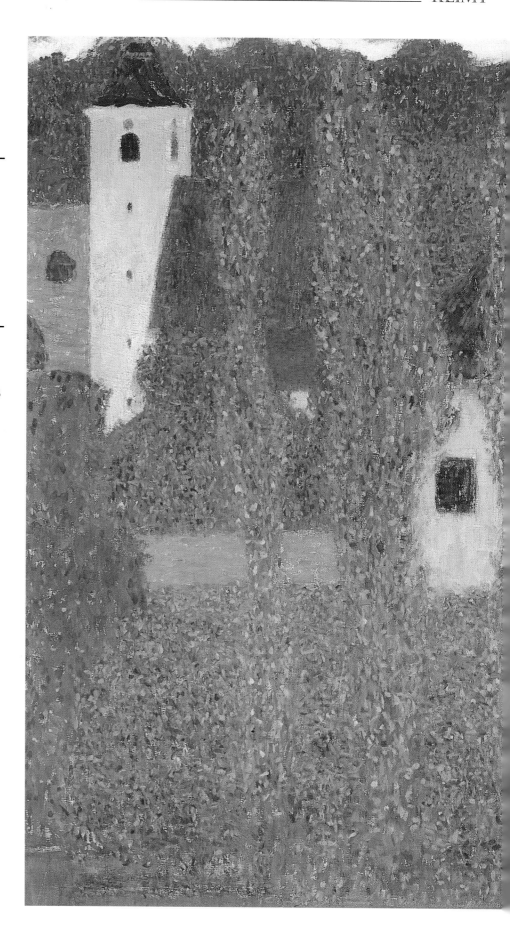

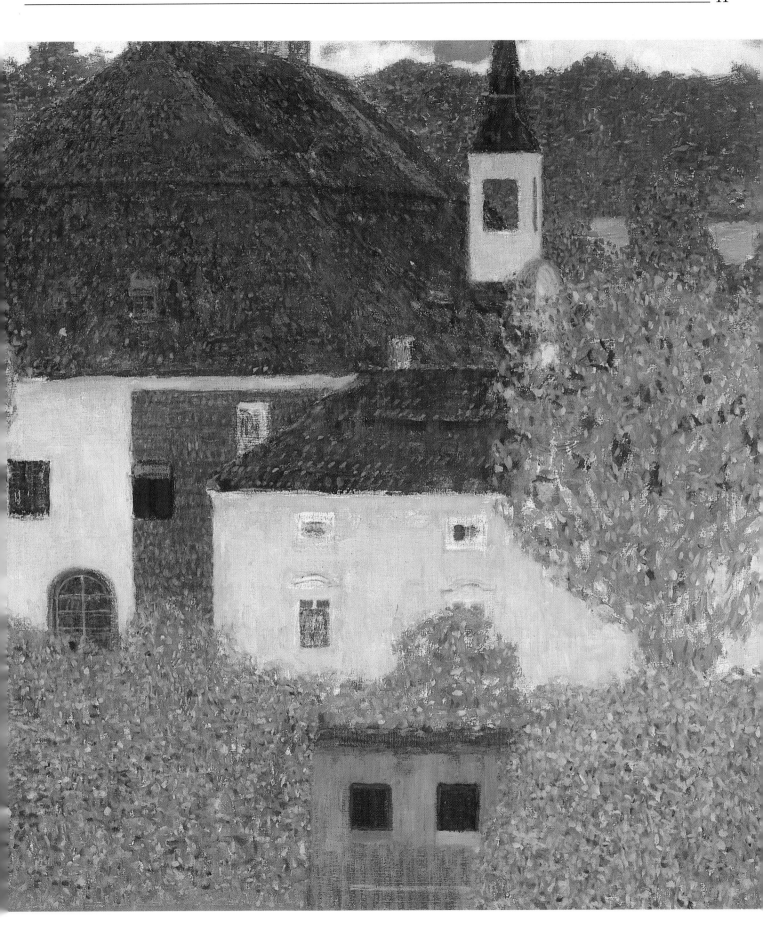

Schloss Kammer on the Attersee I, 1908 (Narodni Gallery, Prague). The castle seems asleep by its calm lake, invoking a powerful atmosphere of tranquillity and harmony. The castle appears to nestle into the small space Klimt has provided for it.

Opposite:
Water Snakes 1, 1904 (detail) (Austrian Gallery, Vienna). The seductive beauty of the gold and of the rich and varied ornamentation, together with the ivory skin tones, dazzle the viewer and distract from the central fact that this is no depiction of fabulous sprites, but rather a naked lesbian couple in a tender embrace.

Klimt sometimes exhibited his pencil and crayon drawings at shows, but more usually they were not for public viewing and were known only to his inner circle of friends. This may have been because most of the drawings are highly erotic and might have been too much to expect turn-of-the-century Vienna to swallow.

In fact, prostitution in Vienna was rife, if risky – the dangers of unreliable contraception and of venereal disease (and, worse, its cure) were ever present – but the city operated a double standard, presenting a face of public morality while the police licensed prostitutes of all ages. Unable freely to express their sexuality or make their fantasies a reality, young men may have dreamt of compliant maidens while fearing witches and harpies. As they were in many periods in history, women were regarded as dangerous and inferior yet idolized; all the while pornography was a major industry. Klimt may have obtained a profound release in making his line drawings, which were more explicit and direct than the meaning-laden allegories and portraits.

The art dealer Gustav Nebehay produced an exhibition of the drawings in 1918, the year of Klimt's death, but it was not until 1984 that a comprehensive catalogue of the drawings was produced, by Alice Strobl. It appears that over 3000 survive out of a possible 6000. The study of Klimt's drawings adds a further dimension to what we know of his character, and confirms the emancipatory nature of his life and work. However, Klimt himself never made any such claim for his work. He pleased himself and did not set out to bring about socio-political changes through his paintings, and the drawings were clearly done for his own enjoyment.

Of course, his allegorical paintings contain a great many figures of nudes, and these paintings sometimes caused offence when they were first shown: but it was not the nudity per se which offended but rather the world view which Klimt presented through them. At the time, nudity in a literary or mythological context was perfectly acceptable. The only time he seriously risked actual prosecution for an offence against public morals was when he published some studies for *Medicine* in an issue of *Ver Sacrum*. Luckily, the courts upheld the view that serious artistic considerations should not be bounded by attention to public modesty.

It is clear from a study of Klimt's erotic drawings that his interest lay, bluntly, in sex. His models pose with abandon, exposing themselves and pleasuring themselves for the delight of the viewer. Many are drawn in close-up or from a foreshortened perspective which emphasizes the sexual element, and the subject never gazes directly at the viewer. Indeed the woman's face is usually shown in repose, almost as if she herself were not engrossed in her masturbation. His women were often drawn so sketchily as to be a mere representation.

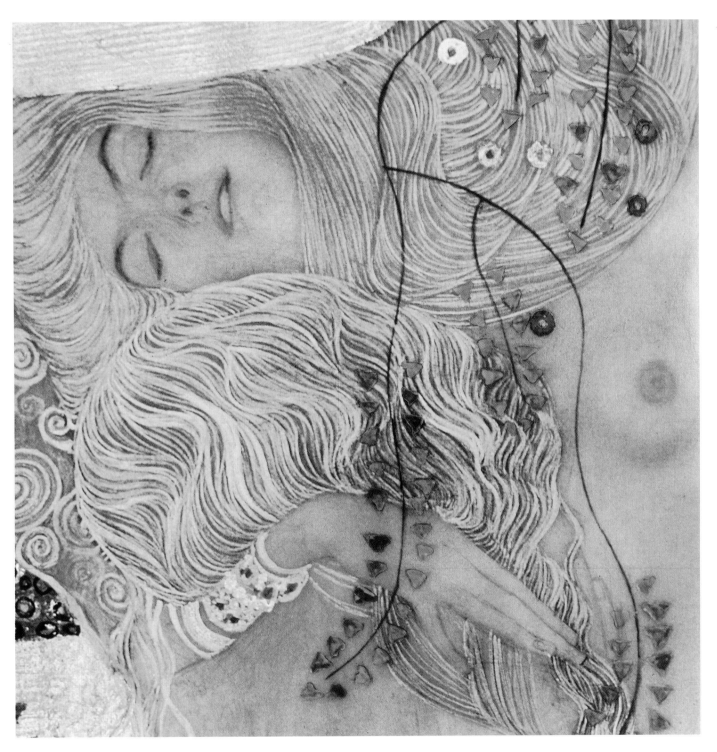

Klimt also enjoyed drawing lesbians together. *Water Snakes*, of 1904, is given a cloak of respectability in its nod to mythology and fable, but actually the two girls are locked in a powerful lovers' embrace.

The drawings contain no spatial context, a feature which can be seen in Klimt's other works. In isolating the figures, Klimt emphasizes a suspension of reality. The drawings are of real bodies, real flesh and

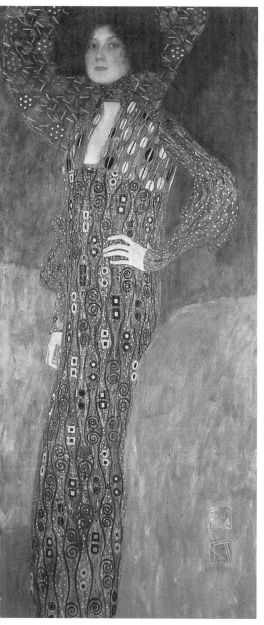

Emilie Flöge, 1902 (Historical Museum, Vienna). This is the first portrait in which Klimt defined the human form as ornament with the ornament itself becoming in a sense organic.

Opposite:
Mäda Primavesi, *c.* **1912** (Private collection). Klimt posed the young daughter of Otto Primavesi, one of his most important patrons and a financial backer of the Wiener Werkstätte, on a wide expanse of Oriental rug painted in gentle colours.

blood; yet they are not of real people. The very passivity of the subjects hints at Klimt's need to control the situation and to manipulate it for his own pleasure, with no requirement to communicate with or to consider the human needs of another person. This isolation gives no autonomy to the women in the drawings. Although they appear completely self-contained, even distant, this merely serves to disengage the viewer.

This process forces the viewer to evaluate his or her own response to the drawings. It is not possible to view them strictly as art: because of their nature it is essential to consider as well one's own involvement. A man might be empowered by the distance and control inherent in the drawings. This fragmentation of the personality from the body is also emphasized by the fact that in many cases only part of the body is shown, or the use of perspective makes it seem that this is the case. He underlines nakedness and draws attention to erotic areas of the body in subtle yet commanding fashion. To do this, drapery and clothes are drawn in such a way as to reveal, to draw the eye to the dramatic central point of the drawing. The very clothing is a peek-a-boo tease, a frame for the sexual element.

A rather sinister view of the female body as fractured is present in much of Klimt's work. This separation is even more a feature of his portraits. However, it is implicit in an artist's work that he should have control over his material, and in the manipulation of his models is evidence that Klimt's control was absolute. In creating the silent world of his erotic drawings, Klimt was the winner, maintaining command not only over the sexual element of womankind but also over his own sexuality.

It is through Klimt's portraits that his evolving style is most easily traced, from his early historicism to an extravagant use of gold and silver in total decoration to his later use of clear colours and looser brushwork. Klimt painted men only rarely – portraits exist of Josef Lewinsky from 1895, and of Joseph Pembauer from 1890, but after that men appear infrequently and then always as adjuncts to women, for instance in *Adam and Eve* of 1917 and *The Bride*, unfinished at Klimt's death.

His early portraits, before the University paintings, owe a debt to painters such as Whistler and John Singer Sargent. *Sonja Knips*, completed in 1898, demonstrates a clever use of light and dark, with the subject placed to one side in the composition and displaying a curious flatness. Even here the picture's design is more important than the sitter's personality. This was even more the case in the 1901 portrait of Marie Henneberg, which was painted to occupy a specific position in the hall of the Hennebergs' new villa, designed by Hoffman and Charles Rennie Mackintosh. The brushwork in this painting shows Klimt's debt to pointillism, though he used the technique to break up

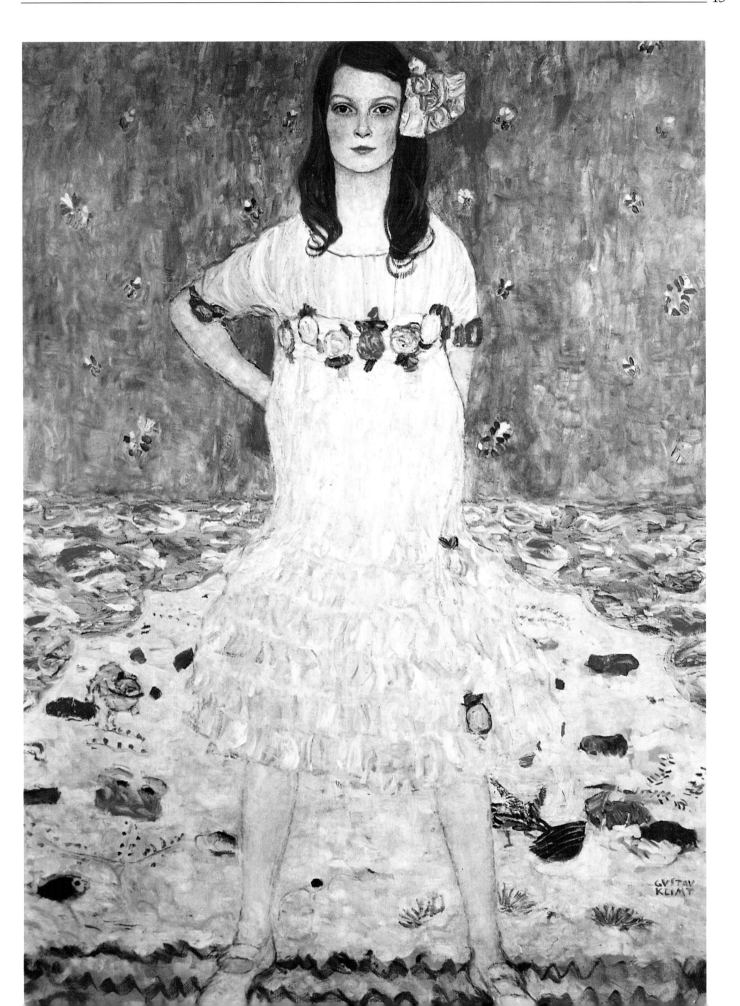

Fritza Riedler, 1906 (Austrian Gallery, Vienna). The stylization of the background is so extreme that even the armchair appears no more than a pattern of ovals. The fan-shaped area of decoration on the wall draws attention to the sitter's head and links it with the rest of the composition, and is ambiguously both pattern on the wall and headdress.

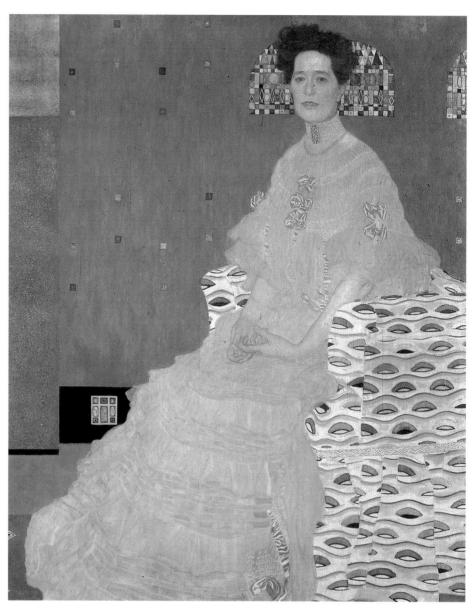

the surface of the picture in an interesting way rather than to enhance the colour structures.

Klimt's 1902 portrait of Emilie Flöge was not a commission and he felt free to experiment; though in the end Emilie was not pleased with the picture, perhaps because it was too experimental. This is Klimt's first use of the vertical format he came to use so frequently, and in it Emilie's body has been reduced to pure ornament. Only her head and hands are rendered naturalistically. Two signature boxes are placed at the bottom right, a borrowing from the Japanese art Klimt had studied which also add compositional weight. The background is plain colour without any depth or realism; the clothes and swirling scarf are filled with tendrils, squares, triangles and ovals. They seize the attention and speak subliminally of eroticism while at the same time denying Emilie's own character.

His 1904 *Hermine Gallia* is more conventional, but his 1905 painting of Margaret Wittgenstein on the occasion of her marriage to the American doctor Thomas Stonborough shows the breadth of his genius. Margaret Stonborough-Wittgenstein was a woman of strong will and intellect, a member of a wealthy and powerful family, but Klimt represented her as a compliant, innocent girl in virginal white, with her hands submissively clasped. It is not surprising that she did not like the portrait and it did not hang for long in her house. The background of the picture is an austere pattern of rectangles in muted colours, and the whites and greys of the dress appear simultaneously dense and transparent. Klimt has concentrated on the design of the painting as a whole rather than on the personality of the sitter and in so doing has produced a decorative icon rather than a portrait.

The 1906 portrait of Fritza Riedler is another composition of interlocking rectangles, with an elaborate use of gold and silver motifs. The armchair is reduced to a pattern of ovals. The decorated area behind the sitter's head is at the same time a pattern on the wall and a headdress reminiscent of those given to the Spanish infanta by the painter Velazquez, and it serves to draw the eye to the head, yet distracts attention from the face. The face and hands are the only fragments of the human which proved impossible to absorb into the decoration. Klimt has rendered his sitter as a mere part of the overall composition, and has subjected her personality to what has been called the 'tyranny of ornament'.

The most fully realized example of Klimt's attempt to reconcile life and art and to transform a human into ornament came with his 1907 portrait of Adele Bloch-Bauer. This work was painted at the peak of his 'golden period' and is intricately decorated, filled with swirls, ovals, blocks, and Byzantine and Egyptian motifs of all kinds, using a technique that includes low relief. One must look hard to find the armchair and the dress. These, and the human form itself, have been fully dematerialized and imprisoned by the decoration; anatomy and ornament have become one. There is no message given by the sitter, only by the iconic use of seductive, shimmering gold, vividly speaking of status and wealth, a rich display of possessions. The use of gold also has magic connotations, and precious metals heighten the erotic charge and sensuality.

This attempt to limit nature through art, to restructure the human personality with ornament, lies at the very heart of Klimt's work. He attempted to subdue femaleness while at the same time he was unable to leave it alone. Images of mutilation run through all his portraits and erotic work, and Adele Bloch-Bauer is no exception. Her head appears organically isolated by her choker, which heightens the tension between the reality of the human form and the two-dimensional aspect of the decoration. Klimt was committed to the aesthetic refinement of

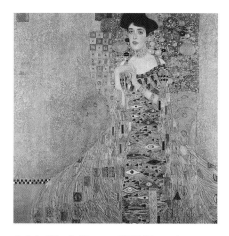

Adele Bloch-Bauer, 1907 (Austrian Gallery, Vienna). This portrait was painted at the height of Klimt's 'golden period' and is absolutely the ultimate in the disappearance of the subject into a background of pure ornament. Only Adele Bloch-Bauer's face and hands remain naturalistic; all other elements in the portrait have been completely consumed by the rich golden decoration.

society and was not interested in politics or social injustice. He considered women to be the property of their husbands: this is evident in the way in which the society matrons he painted are depicted as being no more than the sum of their fine clothes and jewellery, all of course conferred on them by their husbands.

Adele Bloch-Bauer is the only woman who sat for two portraits by Klimt. The second, painted in 1912, is very different. In this she stands, full-frontal, as almost all his subjects would from then on. Klimt used no more gold, but instead bright, unusual colours, applied with loose, thick, brushstrokes. The sitter was still deprived of her body: the contrast between the loose, comfortable, Werkstätte Reform Movement garments she wears and her rigid stance amply demonstrate Klimt's ambivalent attitude towards women. The background is filled with the Oriental motifs Klimt loved, in which the movement of the figures implicit in the vigorous brushwork contrasts with her own passive, flat appearance.

In 1912 he also painted Mäda, the daughter of one of his most important patrons, Otto Primavesi. The young girl's challenging stance is backed by gentler Oriental motifs of birds and flowers painted in clear colours, and her figure is integrated into the design by the triangular shape of her skirt echoing the triangular central section of the carpet. She appears a spirited child, and the open space behind her allows a feeling of movement. Primavesi's wife, Eugenia, sat for Klimt the following year.

The young Elisabeth Bachofen-Echt, Serena Lederer's daughter, had her portrait painted for her wedding in 1914. Klimt posed this beautiful young woman in his usual style, facing out of the canvas. She wears a white gown and is framed by a pyramid of twinkling shapes. Behind her a backdrop of busy Oriental figures live a self-contained life and seem to regard the sitter with interest. With these later portraits, Klimt at last began to show a regard for his sitters' character and to demonstrate some psychological insights.

In 1916 Friedericke Maria Beer requested a portrait; unusually, it was she herself who brought the request rather than, as was more common with Klimt's commissions, her husband. She had just been painted by Egon Schiele, but knew that a portrait by Klimt would confer immortality on her. The characteristic Oriental background contains motifs taken from a Korean vase, and the dynamic little men contrast vividly with the passive figure standing motionless, expressionless.

Quite different in every way are Klimt's landscapes. Out of his *oeuvre* of some 230 pictures, fifty-four are landscapes.

In 1897 he went for the first time with Emilie Flöge, her mother, and her sisters to her family's holiday home on the Attersee, in the

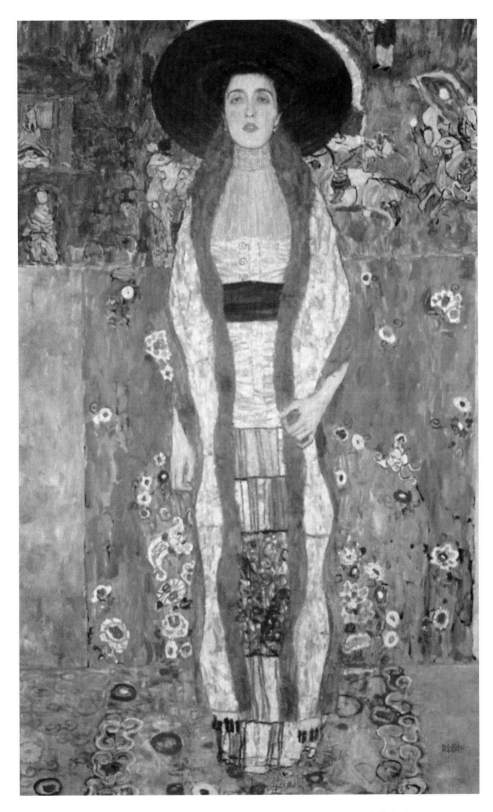

Adele Bloch-Bauer II, 1912 (Museum of the Twentieth Century, Vienna). The vividly coloured background filled with flowers and prancing horsemen, painted with thick, daubing brushstrokes, is a foil for the figure standing stock still and hidden within the dematerializing curves of her clothes. Only Bloch-Bauer's face and hands are visible and although her gaze at first appears direct it is actually introspective.

Salzkammergut region of the Alps in Upper Austria. This is an exceptionally beautiful region of lakes, forests, and mountains, where those Viennese who could do so liked to go for the summer months to exchange the heat, noise and dust of the city for the cool, fresh air of

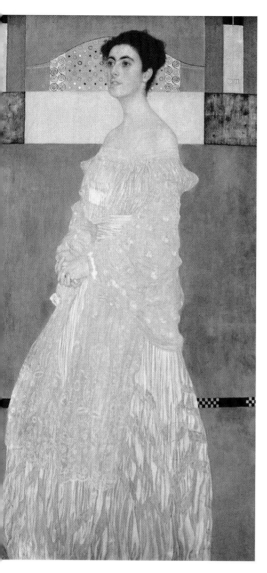

Margaret Stonborough-Wittgenstein, 1905 (Bavarian State Collection of Paintings, Neue Pinakothek, Munich) Margaret Wittgenstein did not like this portrait, which was painted for her marriage to the American doctor Thomas Stonborough.

Opposite:
Elisabeth Bachofen-Echt, 1914 (Lederer Collection, Geneva). Painted for her wedding, this painting shows Elisabeth Bachofen-Echt as a central pillar within a series of triangles formed by the Oriental figures behind her.

the country. The Flöge family preferred to stay in the little village of Kammer, a rural spot which had only been accessible by train for some ten years. Other resorts were grander, but Kammer was quiet and unpretentious, and provided exactly the retreat Klimt needed from the pressures of life in Vienna. For the rest of his days Klimt was to spend the summer months on the Attersee, an invaluable safety valve for his busy life.

Here his routine was as settled and gentle as he liked. A rare letter to Mizzi Zimmermann survives, in which he describes his day. He would rise at about six in the morning, do some painting, go for a swim in the lake, read, nap, perhaps visit friends, go rowing on the lake or walking, and retire early to bed, ready for the next day. He was able to spend time in Emilie's company; he could relax.

The year 1897 was for Klimt a year of demanding involvement in the birth struggles of the Secession Movement, and for a man who at bottom was reluctant to stand centre stage, it must have been a huge effort to survive the very public controversy. At this time he was also painting the first of his University paintings, *Philosophy*, and the work was making great intellectual demands upon him. He needed a holiday: not a holiday from painting, only from painting as he undertook it in Vienna. Klimt found himself a change of subject. He painted his first landscape that year, when he was thirty-five years old, and found it enormously relaxing. He was able to work very fast, and in the next five years he completed no fewer than fifteen canvases.

Klimt left no drawings of landscapes, only finished paintings: he probably did make preliminary sketches, but these have not survived. He worked outside, only sometimes finishing a painting in his studio back in Vienna and relying on photographs as well as sketches for help. We have descriptions of Klimt setting off in the morning with his paints, canvas, and easel, sometimes on foot and sometimes in a rowing boat. He used a pair of binoculars to look more closely at motifs which interested him, and a cut-out viewfinder to find a promising view. This method of working in effect turns his landscapes from broad vistas to close-ups, causing the viewer to focus only on a small part of what is a large subject and emphasizing how much has passed beyond the scope of the canvas.

The first of his landscapes, *Orchards and Farmhouse with Climbing Rose*, has an upright format, as do the next three. They are atmospheric and melancholy, and seem to contemplate the growth of an organic matter independent of mankind. This slow growth even extends beyond the frame of the painting. Klimt's landscapes are almost entirely devoid of human life or narrative element, and so seem to hint at a complete reversal of his usual interest in portraying the human body. In fact, his 'Viennese' paintings do not contain

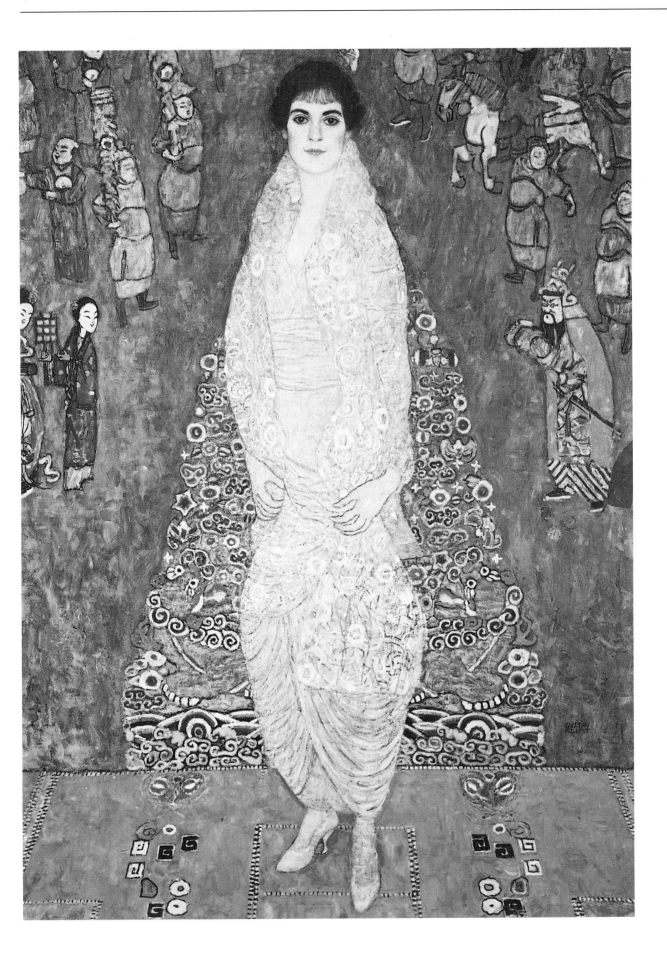

landscapes, and only the portrait of Sonja Knips and one of his early portraits of Emilie contain flowers or foliage of any kind.

In 1899 Klimt painted a landscape in square format, quite large – about a metre square – and did not thereafter deviate from this format. The square shape enhances the atmosphere of tranquillity and stillness which is reinforced by the absence of any movement or activity within the painting. The paintings are filled with subtle interior shifts of tone and lighting. In many of the paintings the horizon is raised, which changes the perception of gravity and amplifies the mood of calm. In some, there is no horizon at all, and so the illusion of depth in a conventional landscape is replaced by an illusion of landscape as a pattern. The subject of the painting seems to hang as if from a picture rail, like a piece of embroidery, seemingly at one with the artificial. Klimt suggests perspective with the use of an overlapping technique in which objects in the foreground demonstrate their closeness by partially covering other objects, further away. This technique is found in Japanese painting, and Klimt would have been familiar with it not only from his long hours of research preparatory to his work on the Museum of Art History in Vienna, but also from his own collection of Oriental art. Used in landscapes which at first sight appear almost Impressionistic, the technique is especially effective.

Klimt's bottom-heavy use of space is also typical of Oriental art, and indeed of *art nouveau* as well. This asymmetrical dispersal of mass is an effective dichotomy in Klimt's characteristic square frames, and is certainly his trademark. He understood the artistic tensions it was possible to create within a superficially restful picture by using this narrow band of sky to offset a densely embellished foreground. Even if the foreground actually took up the entire picture, the horizon might be suggested as a dramatic element in the mixture of the natural and the arranged. The hypnotic quality of the landscapes was further obtained by the use of both horizontal and vertical parallels, as in *Schloss Kammer at Attersee I*, painted in 1908. The use here of what might almost be called blocks echoes the square format of the paintings, and in its squaring of nature also brings it under control. As with Klimt's erotic drawings, the artist is in charge not only of what the viewer sees, but how he sees it.

As well as studies of forests, Klimt's leit motifs include old cottages, fruit trees, and lakeside scenes. He mainly avoided the influence of Impressionism and pointillism, and although he may have been influenced by the spare, mysterious landscapes of Khnopff, the only landscapes it is possible to compare with his are those of Van Gogh. Yet Van Gogh's heavy, separated brushstrokes signpost the artist's despair and need to anchor himself to the earth, while Klimt aimed to paint something altogether lighter. Seurat, the inventor of

Overleaf:
Farm Garden with Sunflowers, 1905-6
(Austrian Gallery, Vienna). This painting is more pure pattern than naturalistic depiction of a garden of flowers. A jewel-like effect is obtained by the rich orchestration of clear colours and the tumbling abundance of flowers and foliage in all shapes and sizes.

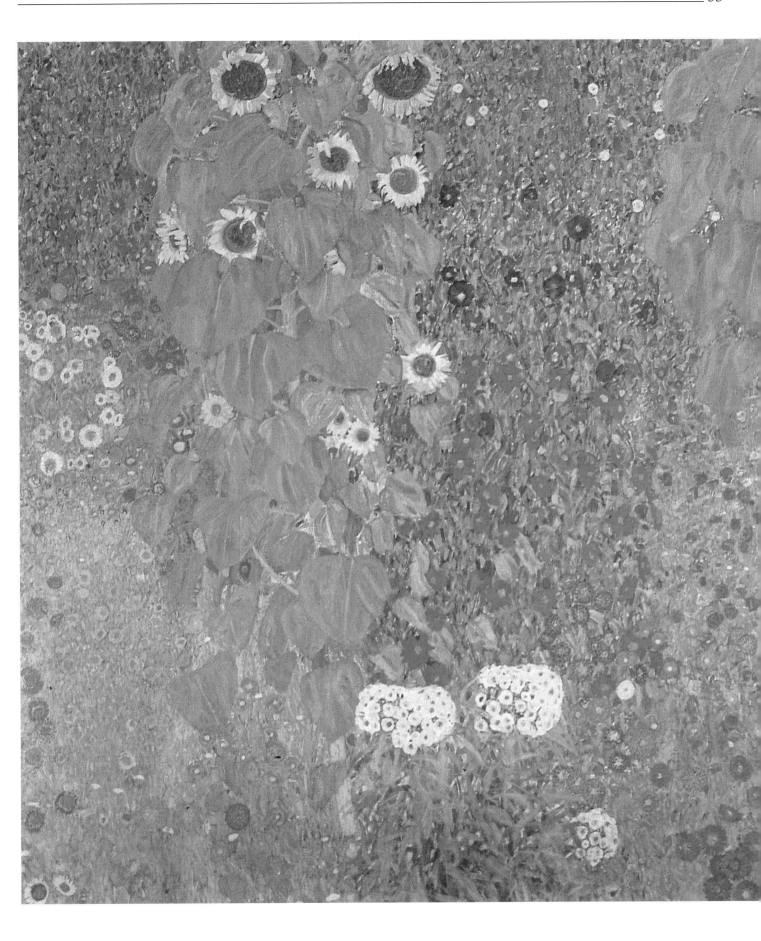

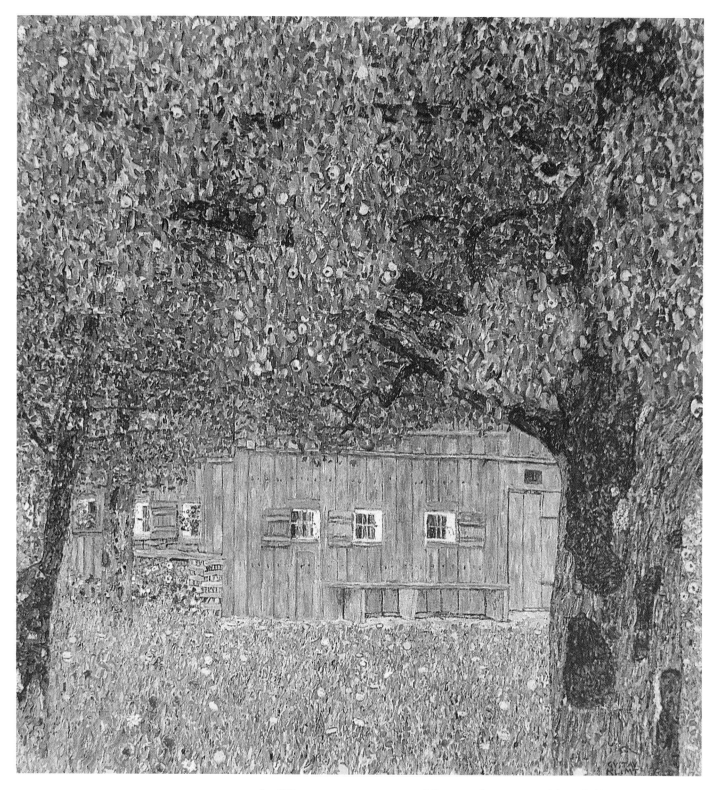

pointillism, never went to Vienna, but one of his followers, Signac, exhibited at the 1900 Secession show, and the technique became popular in Vienna. Klimt, however, preferred to use his dots and short brushstrokes to create spatial ambiguity and rich decoration rather than a natural landscape.

He wanted to get behind the naturalistic form and probe to the very heart, the essence of nature. Through this, his landscapes seem even to surpass those of Whistler or Monet in their sensitivity. In the same way that he preferred to put a message across in his allegorical paintings, so rather than provide a tangible description of a place he liked to demonstrate the changing pace of life, the slow and invisible growth of plants. The vitality of nature is inherent in his landscapes, but it is seldom explicit. He avoided the use of human forms, and indeed only infrequently did he use animals. Chickens appear in the early *After the Rain*, and again in *Garden Path with Chickens*, but in their shape and colour their purpose is to form a link between the riotous flower beds on the two sides of the path.

The Black Bull, painted in 1901, is a powerful depiction of a huge, vigorous creature, with a surface message of fertility and growth. But much of the picture's impact derives from the fact that the bull is tethered inside a barn, its power fettered and confined.

Klimt's calm landscapes allow the viewer to relax into contemplation of a peaceful world. The paintings are not dynamic but gentle, allowing a restful atmosphere to envelope the beholder. Yet in some ways there are links between these serene landscapes and the dramatic allegories. Although the places Klimt painted are often still recognizable today, they are decoratively transformed in much the same way as so many elements in his other types of painting. They seem almost to be self-contained, lacking exterior points of reference; lacking even any evidence of human occupation. Silent nature was accorded the same interior dignity as the intimate emotions of the human spirit.

Farmhouse in Upper Austria, painted in 1911, is one of the paintings in which a house is shown. A peasant cottage is set among fruit trees in a flowery meadow. Only part of the cottage is visible through the foliage, and it appears an organic part of the natural world surrounding it. This device, in which human habitation is subsumed by nature, increases the atmosphere of timelessness, of a place independent of human time-keeping, where reality can be suspended. *Farmhouse with Birches*, of 1900, also has a portion of a cottage peeking through the dense woodland at the horizon of the picture. However, the painting is dominated by the dappled meadow and four slender birch trees, whose spacing on the canvas leads the eye up and back, from the loose brushstrokes in the foreground to the smooth background.

The paintings set on the lakeshore, such as *Church at Unterach on Attersee*, are also linked with such paintings as *Water Serpents*, *Fish Blood* and *Mermaids*. In all these, water carries a symbolic charge connected to the idea of water as the source of life. The towns themselves show no sign of life. They are reflected in the motionless waters of the lake, and their topmost parts pass out of the frame. They brook no change; they contain no possibility of development. They are

Farmhouse in Upper Austria, 1911-12 (Austrian Gallery, Vienna). The close focus of this view of a farmhouse nestling among trees gives the picture the feel of an interior. There is no horizon or sense of empty space, and the overwhelming atmosphere is of silence and stillness, of desertion.

almost claustrophobic in their static atmosphere and narrow perspective. Nature is emphatically denied the upper hand.

Klimt painted several views of the Attersee itself, often with one of its islands perched right at the very top of the frame on the horizon. To paint *Island on the Attersee*, 1901, Klimt would probably have rowed out on to the lake and thus obtained his clear and uncluttered viewpoint of the little island of Litzlberg. The painting is almost monochrome, with an expanse of soothing blue water nearly filling the canvas, the horizon and island depicted in a violet colour echoing the extreme foreground. The expanse of water is given depth and coherence by Klimt's short stabbing brushstrokes. Although at first sight it appears almost abstract, this minimalist, modern work recalls Monet's *Waterlilies*.

In Klimt's series of paintings of forest interiors, such as *Beeches* of 1900, or *Beech Forest I*, painted in 1902, or the very similar *Birch Forest* of 1905, the trunks of the trees set up a rhythmic sequence reminiscent of the stone columns in a cathedral, and have the same tranquil effect. The trees seem to stretch out to infinity, with the uniformity and repetition paradoxically expressing infinite variety and the links between the momentary and the timeless. The foreground seems very close, almost as if the artist were lying down among the leaves on the forest floor. Behind, where we see only fragments of certain trees, we are reminded that in the real world we see only fragments of reality.

The 1910 painting, *The Park*, is a dense space in which it seems that Klimt was not able to leave a single inch unfilled. At first glance it appears to be one mass, and it is not until one inspects closer that it is possible to distinguish the trunks of individual trees. This clarity is achieved only by the careful composition of a large number of small elements. As one studies the painting, patterns emerge, and, in shifting one's eyes, a new set of patterns becomes visible. It almost seems as if it is a mosaic puzzle, with only scant clues to its interpretation.

Klimt used gold paint in his landscapes less frequently than in his allegories or portraits, but where it appears it gives a three-dimensional quality to works which could often appear more two-dimensional. In *The Golden Apple Tree*, painted in 1903 (and one of the paintings destroyed at Schloss Immendorf in 1945), the golden apples appear to float like sparks in the dark branches of the tree, and the effect is that of fireworks in the sky at night. Later, as Klimt tapered off the use of gold in all areas of his work, a jewel-like effect was obtained by a rich orchestration of clear colours. In *Flower Garden*, painted in 1905, the blooms burst from the background in a profusion of colours.

Klimt painted sunflowers on several occasions, perhaps influenced by Van Gogh, who had showed at the 1903 Secession Exhibition. In *Farm Garden with Sunflowers*, painted around 1905, a dark background is starred with sombre-coloured flowers, and a tall sunflower

Birch Forest, 1905 (Gemaldegalerie, Dresden). This forest interior, with its raised horizon and rhythmic procession of tree trunks, has a hypnotic quality. Nature yields to pattern and to the force of the decorative elements, to the interplay of form and colour.

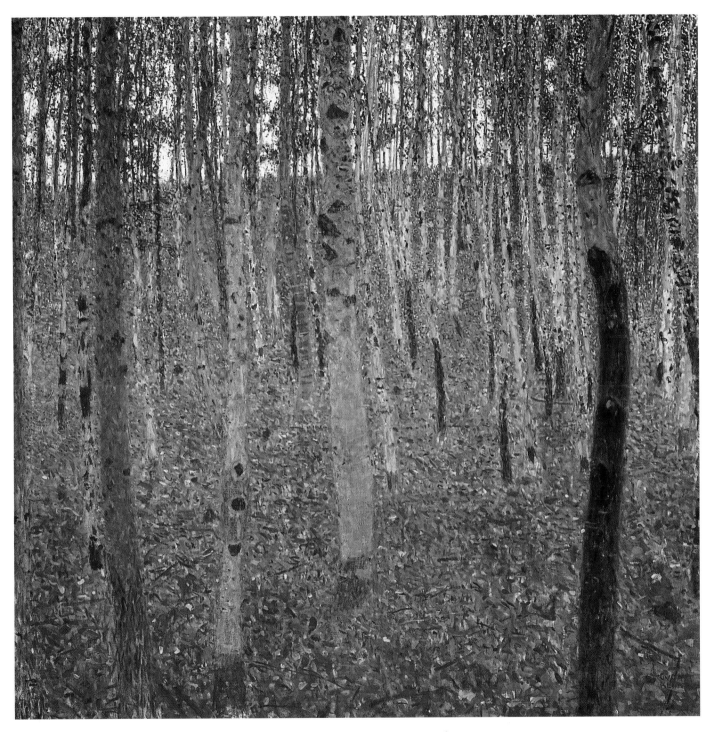

rears up to the very top of the canvas. Its brilliant blossoms erupt from the darkness and illuminate the whole painting. *Sunflower*, painted in 1906, depicts the sunflower itself as a tall pyramid shape surrounded by an abundance of smaller flowers and foliage in a variety of colours and shapes. The sunflower hangs its head; it is impossible not to feel the emotional power of the anthropomorphic attitude of resignation and solitude. In many ways the painting is reminiscent of Klimt's portraits, with only the face visible and the 'body' swathed in decoration.

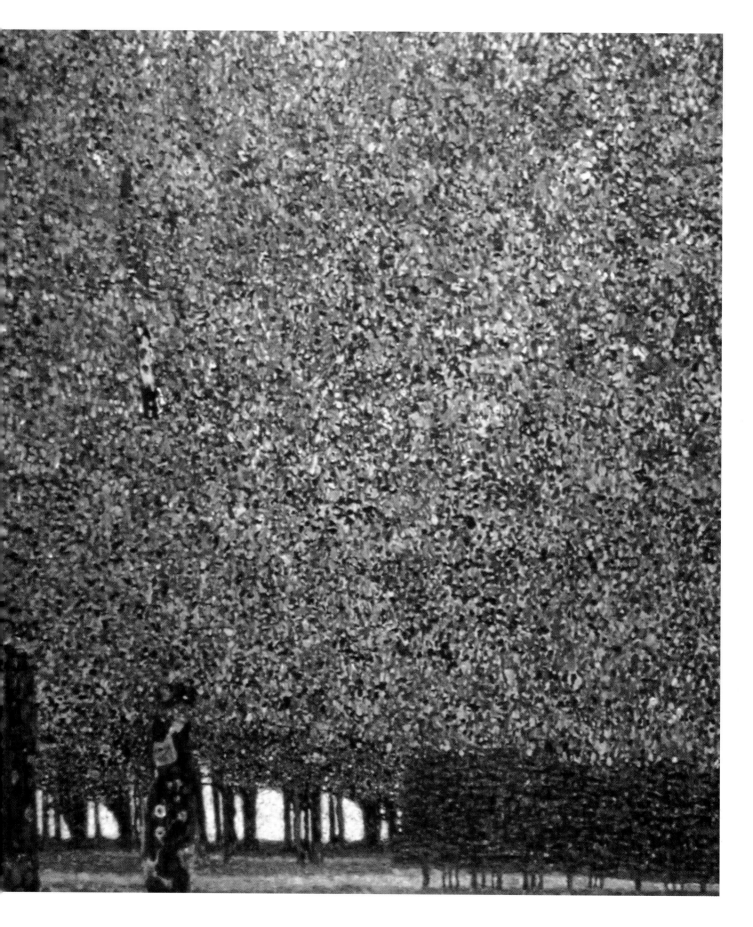

In maturity, Klimt seemed to be less concerned with the creation of atmosphere, than with realism and the capture of an anonymous life impulse. He began to emphasize architectural motifs from about 1908, the year in which the Klimt Group broke away from the Secession. By 1910 he had already painted the Schloss Kammer several times, and each time the depiction was more realistic. His 1912 painting *Avenue in Schloss Kammer Park* is again reminiscent of work by Van Gogh, with its heavily outlined tree branches and asymmetrical viewpoint; even in its use of colour – the greens, yellows and aquamarines. Other views of the Schloss Kammer provide a broken perspective, with both side and front of the castle in view, an arresting device which gives the viewer pause for thought. His 1911 painting *Farm Garden with Crucifix* is especially interesting. The little garden crucifix and virgin are among trees; a small corner of a cottage can be seen to one side. The flowers in the grass seem to be flowing upward, surrounding the religious icon with a starry cloud; or perhaps a carpet. The figure of Christ on the Cross is the only human figure from all the landscapes to be shown in such detail; and the paradox is that it is a carved representation of a human only. Nature is the dominant force here.

By 1915, the painting *Park at Schönnbrun* demonstrates a mood of mature reflection. Indeed the reflection in the water appears more important than what is being reflected. This late painting has a tranquillity which surpasses even that of the very early canvases.

Klimt's emotional engagement in his landscapes is unmistakable. They stimulate mood and heighten one's response to nature. They usually invoke repose but sometimes instead delight in the jewel-like painting. They can be seen as a whole or as a series of individual paintings. During Klimt's lifetime the landscapes received less critical attention or public acclaim than any of his other works, and even since his death they have been overshadowed by the tremendous popularity of pictures such as *The Kiss*. But they are undoubtedly some of the loveliest landscapes of this century.

The Park, 1910 (Museum of Modern Art, New York). At first sight this is an abstract painting in green, blue and yellow with a mosaic-like quality, and it is only on close inspection that one discerns the individual tree trunks at the bottom of the frame.

CHAPTER 4
Allegories

From the very start of his career, Klimt had been interested in classical imagery and in allegory, enthusiasms which had been encouraged and honed by the education he received at the Art School.

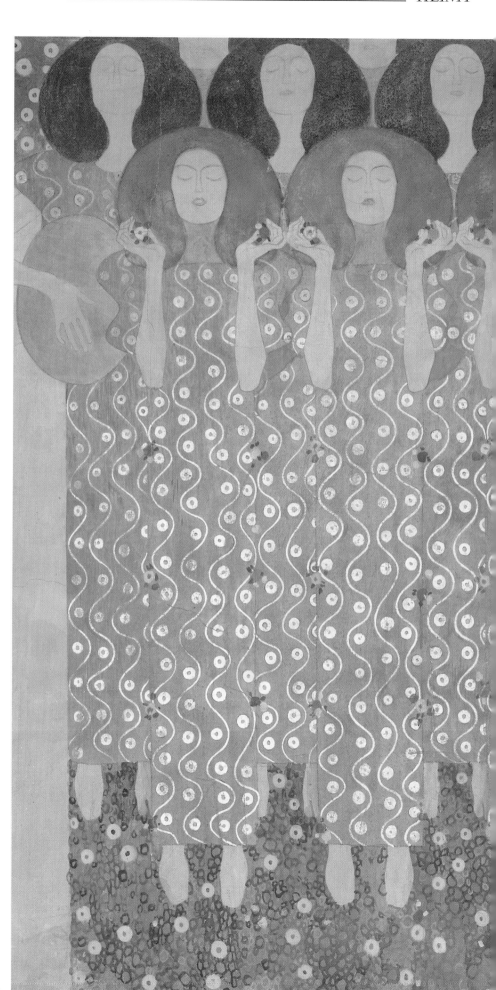

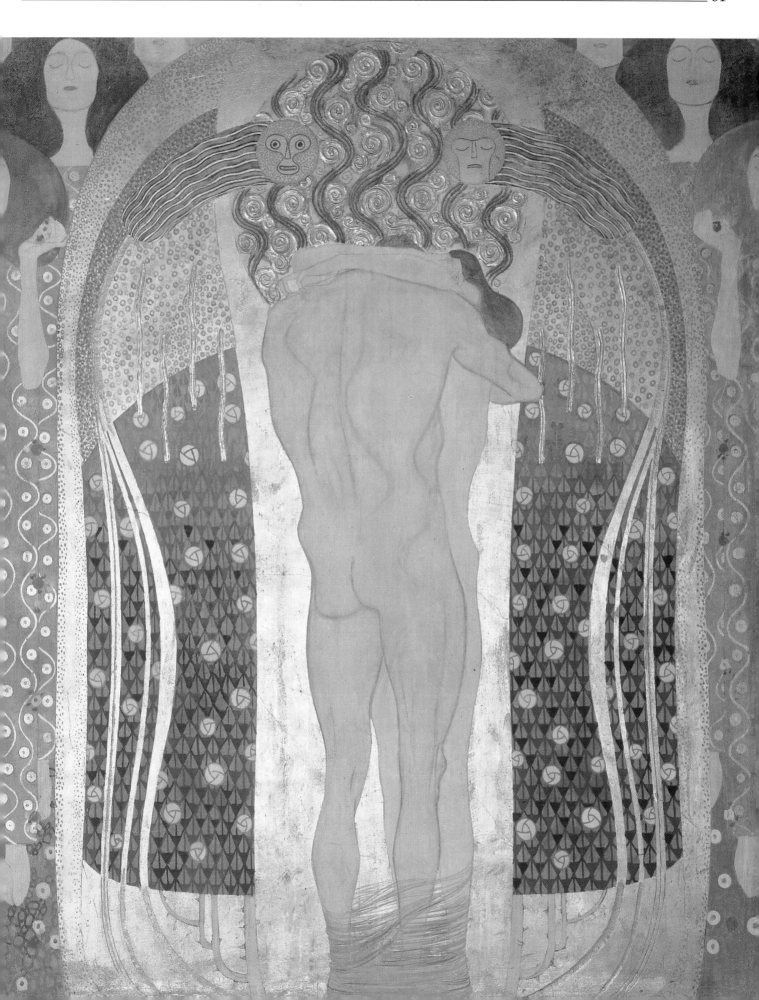

Overleaf:
A Kiss for the Whole World, Beethoven Frieze, 1901 (Austrian Gallery, Vienna, on loan to Secession). The final redemption is reached, the man is saved. The lovers stand unmoving, meshed at the feet and bowered in gold, the woman almost completely hidden by her nude lover. The kiss is oddly private and exclusive for an embrace designed 'for the whole world'.

Opposite:
Hygeia (detail from Medicine), 1900-07 (destroyed by fire 1945). The Greek goddess of health carries her traditional cup and snake. She stands, vivid in red and bright gold, gazing down at the viewer – Klimt has used a provocative perspective, up from below, which makes Hygeia appear to loom out of the painting.

Klimt's early commissions, the historical paintings in the Museum of Art History and his decorations at the Dumba Palace, were painted in the allegorical language well understood by the educated, bourgeois Viennese art lovers of the time. Their preference was overwhelmingly for art which glorified the Empire, which harked back to a spurious classical past; a past which, nourished by the extravaganzas of Hans Makart, existed mainly in their imaginations. Klimt had no thought of changing the course of the artistic establishment. His one ambition was to be a great painter in the mould of Makart.

When he was commissioned to contribute to a series of books on emblems and allegories, Klimt was able to produce with great facility prototypes on such subjects as *Youth, Fable,* and *Idyll.* Better known perhaps are *Sculpture, Tragedy,* and *Love,* painted for the second series of books. Here for the first time are present some of the elements which later came to characterize Klimt's work: the use of gold paint, an Oriental aspect and, above all, the introspective female face. The pieces are technically perfect, but they represent an artistic tradition which Klimt soon realized lacked relevance for him. *Love* in particular is a syrupy confection: a virginal young lady in white flounces is romanced in soft focus by a moustachioed gentleman within a gilded frame decorated with fat pink roses. The whole is heavy with sentiment. However, above the lovers appear three women's faces, representing the three ages of women, and this motif is an early statement by Klimt of the need to look beyond the direct message in the painting. These hovering background figures were to become a recurring feature of Klimt's allegories, with their wider meaning an attempt to find an allegorical rhetoric which could be understood by his audience.

All was to change with the notorious University paintings. The University had been dispersed among several sites in the city for almost fifty years, and its relocation to one of the new Ringstrasse buildings held a particular significance in the city. Unfortunately, by now Klimt and Matsch had become estranged, for reasons which are not clear but which may have been personal, and the work went slowly. It is clear that Klimt was by now struggling with the constraints of trying to produce conservative works, and indeed found that he was no longer able to do so. It was not until 1896 that there was even a detailed plan of work to place before the Ministry of Education's Artistic Committee, and it was a further four years before Klimt was to hang *Philosophy,* still unfinished, at the second Secession Exhibition in 1900.

The changes in Klimt's thinking were becoming evident in other works produced during this time. Undertaken for the decoration of the Music Room at the house of Nicolas Dumba, his painting *Schubert at the Piano* clearly shows the beginnings of his change of style. Instead of

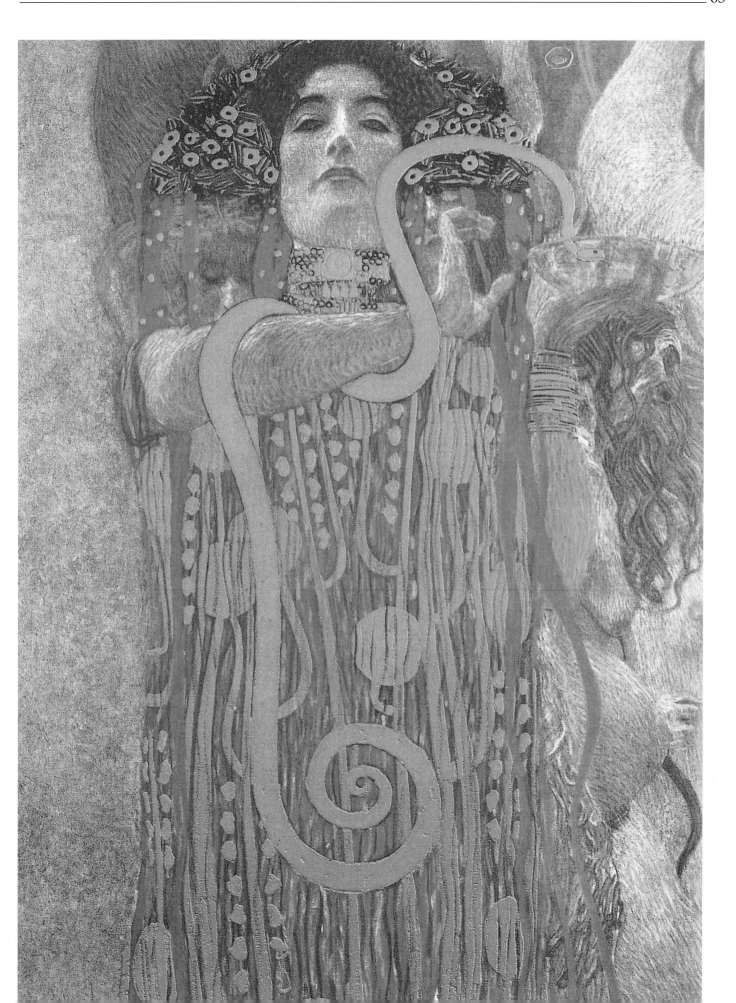

Pallas Athene, 1898 (Historical Museum, Vienna). Pallas Athene, patroness of arts and crafts and here helmeted and armoured in gold, was adopted by the Secession as its emblem. Further symbols are the naked figure of Victory she holds, and the head of Medusa on her breastplate, poking out her tongue at the enemies of the Secession.

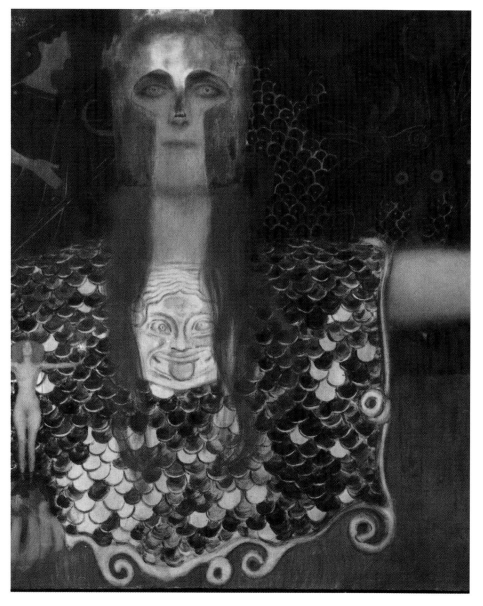

Opposite:
Goldfish, 1901-2 (Private collection). Although the eye is drawn to the glittering goldfish, the picture is dominated by the exaggerated backside of the girl at the bottom, smiling saucily over her shoulder.

a slavishly correct historical painting, the work sets out to create mood, and the light brushstrokes contribute to the glowing atmosphere.

In 1898 came *Pallas Athene*, a strikingly golden portrait of the goddess who as patroness of arts and crafts was adopted as the Secession emblem. Her allusions to wisdom, heroism and the triumph of integrity were also important to the Movement's view of itself. The portrait is contained within a beaten copper frame, made to Klimt's design by his brother Georg. The protagonist herself, in *Pallas Athene*, wears a golden fish-scale breastplate containing a mask of Medusa, cross-eyed and sticking out her tongue. Athene's helmet of burnished gold leaves visible only her eyes and mouth, a device which looks forward to Klimt's later portraits in which so much of his sitters is concealed. She holds in her right hand a miniature version of herself as fair-haired Nike, the goddess of Victory. In the background Hercules

does battle with Triton. Athene is a powerful, adamant-looking woman with a determined jaw and long red hair, and Klimt liked her enough to reproduce her, in slightly simplified form, in the third issue of *Ver Sacrum*.

The following year Klimt enlarged the little Nike into his *Nuda Veritas* of 1899, in which naked truth holds a mirror to the world while the snake of falsehood is coiled dead at her feet. The snake is also perhaps a symbol of male presence. Perhaps the most significant feature of the work is the lettering at the top, on the gilded frame, a quotation from the German dramatist Schiller:

> *If you cannot please everyone with your actions and your art, please a few. It is bad to please the majority.*

Klimt was explicitly laying out his new stance, that he would no longer aim to reach anyone's standards but his own.

By 1900 Klimt's *Philosophy* was still not finished, and he would not have agreed to hang it at the second Secession Exhibition, except that the most prominent position had been reserved for it. So, despite his reservations, up went the picture. Klimt must have known that the result would be a furore. The programme notes, which make a brief attempt at an explanation of the picture's meaning, read:

> *Group of figures on the left: becoming, fruitful existence, passing away. On the right, the earth's sphere, the mystery of the universe. Appearing at the bottom, a figure that illuminates: Knowledge.*

There was an immediate recoil among not only members of the public but also the members of the University, who felt both perplexed and offended. *Philosophy* depicts a column of intertwined human shapes, embracing couples, children, old men and women, to the left of the canvas, with a background of hazy, starry space inhabited only by a vague, half-formed face. At the very bottom of the canvas is a sphinx-like face, gazing steadily out from her darkly billowing hood. What did it mean? The critic Ludwig Hevesi understood at once: the mysterious fermentation of the universe, the elemental chaos throwing up forms and enigmas, are all only capable of interpretation with the help of Knowledge, of Philosophy. Thus, only with the help of Philosophy is it possible to make sense of Life.

Hevesi knew the painting would prove incomprehensible, and he was right. Almost at once eighty-seven members of the University had published an open letter denouncing the work as ugly and unclear. The Rector himself, Wilhelm Neumann, told the press that philosophy 'which today takes its lead from the exact sciences, does not deserve, especially now, to be represented in nebulous, fantastic imagery, as an

enigmatic sphinx'. Klimt himself came in for personal criticism – among other things, he was accused of being too ignorant and poorly educated to have grasped the principles of philosophy.

However, Klimt did have supporters, among them the University Professor of Art History, Franz Wickhoff, who gave a lecture entitled 'What is Ugly?' in which he warned of the dangers of judging beauty only by the standards of the past, and Hermann Bahr, an influential

writer and critic (he owned *Nuda Veritas*), who organized a protest in Klimt's favour. The controversy raged for months – Viennese society liked nothing better than scandal and debate, and very few were convinced of the painting's legitimacy as an honest attempt to deal with a complex, abstruse subject in an original manner. Even when the picture was awarded a prize at the Paris World Fair, Vienna remained dubious, and there were loud demands that the University should cancel the commission.

The Minister of Education, Dr Ritter von Hartel, unexpectedly supported Klimt and refused to do so. Klimt continued to work on the second panel, *Medicine*, which he exhibited in 1901 and which caused as much fuss as *Philosophy* had previously. The work was intended to occupy the opposite corner of the ceiling from *Philosophy*, and thus the composition is almost a mirror image. Again there is a nebulous background occupied, this time on the left, by a single figure; on the right is a tower of clinging human forms. At the bottom stands Hygeia, the Greek goddess of health. She is traditionally shown holding a cup and a snake, and Klimt shows her with both. She gazes steadily out of the picture, as Knowledge does from *Philosophy*. Above her a young, naked woman seems to float freely: shown in a foreshortened perspective from below it is her sex which draws the eye.

It was this nude, as well as the writhing column of agonized figures, among them skeletal Death, which caused the scandal. This time Klimt was accused of pornography as well as of omitting any mention of the healing powers of medicine. Instead he appeared to have concentrated on the very opposite, on the inability of medicine to influence the course of disease.

Again Dr von Hartel refused to cancel the commission, despite the fact that this time the issue had even been contested in Parliament, the first cultural issue ever to be so debated. Perhaps surprisingly, Klimt was elected to a professorship at the Academy in 1901; however, the Ministry of Education refused to ratify the position, and Klimt never again sought a public position. He must by now have realized that his path was to diverge radically from the broad highway of convention.

Klimt continued to be defended publicly by both Hermann Bahr and Ludwig Hevesi, who understood that the controversy had wider implications for Austrian art. The debate had already taken place in other cities such as Paris and had been resolved. In Vienna it had not yet been accepted that it was legitimate to express the greatest – and the least – mysteries of life by means of allusion and implication.

Although Klimt did not relish the misunderstanding and public polemic which attended the first two University paintings, he felt able to respond, in 1902, with the exhibition of *Goldfish*. This tall, thin painting does contain a goldfish, and golden bubbles bursting through the water besides: but its main feature is a water sprite with flowing hair

The Three Ages of Woman, 1905
(National Gallery of Modern Art, Rome)
The stages of a woman's life and aspects of womanhood are represented here. The mature woman and her child are unaware, innocent. The old woman reflects despair at the approach of death.

who crouches at the bottom of the frame. She looks over her shoulder at the viewer, and seems insolently to be presenting her bottom. It is said that Klimt wanted to call the picture 'To my Critics', and it certainly has something of a jeering quality about it.

Meanwhile Klimt was pressing on with the third and last University painting, *Jurisprudence*, and this, together with the other two (still unfinished) he hung at the Secession Exhibition in 1903. The University had approved an original design showing Justice brandishing her sword, and its members were horrified to see the final work. Indeed the painting is a highly complex and individualistic work, in a style very different from the previous two, but apart from the interpretation, which as before was not what they wanted to see, the main objection was that the design was completely different. Klimt appeared to have concentrated not on Justice, but on retribution and torment. The picture is dominated by the central figure of a naked man, bent in shame, surrounded by three torturing female figures and grasped in the tentacles of a giant octopus, representing Conscience. In the far background stand Truth, Justice, and Law, seeming by their very distance uninterested in the proceedings before them. The allegory centres not on the rule of law, but on the fate of law-breakers.

Further, the painting is more abstract, with no real attempt to depict space or perspective, and uses mainly black, red and gold. This time the objections were perhaps more valid: the painting would not have fitted in with the other two by Klimt, nor with the work being done by Matsch, and nor for that matter into the ornate rococo style ceiling. Although the University did accept the paintings they decided that they could not be used in the University, and a compromise was reached: the paintings would instead hang in the new Museum of Modern Art. Then, in 1904, the University refused to send the paintings to the World Fair in St Louis as part of a selection of work to represent Austria. This was the last straw for Klimt. He informed the University that he had not begun the ten spandrel paintings, and would not do so: he would not hand over the three ceiling paintings; and he would repay his advance.

This he did, with the help of his patron Auguste Lederer. Only in 1907 did he feel able to complete the paintings. Auguste Lederer later bought *Philosophy*. He also owned the *Beethoven Frieze*, which had been purchased by the industrialist Carl Reininghaus, who removed the work from the Secession Building and later sold it to Lederer. Klimt's friend Koloman Moser bought *Jurisprudence* and *Medicine* in 1911, and on his death *Jurisprudence* passed to Lederer while *Medicine* was bought by the Austrian Gallery. The Nazi Government confiscated the Jewish Lederer's property, including the Klimt collection, during the Second World War and took the paintings (along with others from the Austrian Gallery) for safekeeping to Schloss Immendorf, a castle in

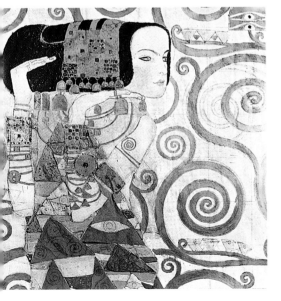

Expectation, 1905-09 (detail) (Austrian Museum of Applied Art, Vienna). The figure is a wholly integrated part of the overall design of rich Byzantine whorls. Her robe is patterned with triangles and stripes of pale colours and she has a stylized, Egyptian demeanour.

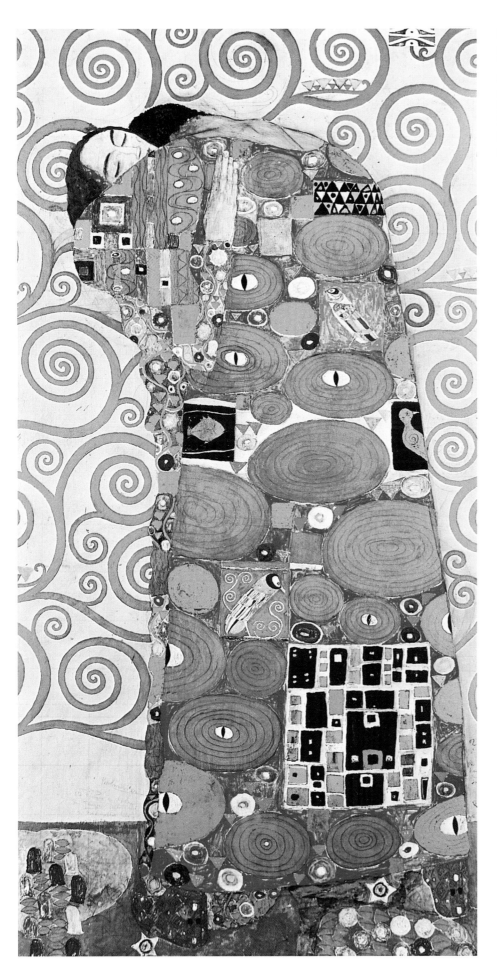

Fulfilment, Stoclet Frieze, 1905-09
(Austrian Museum of Applied Art,
Vienna). Here the background and the
figures of the lovers merge into one
decorative element; the humans have
been stylized into inorganic objects.
However, the beauty of the decoration
is almost more important than any
message.

Lower Austria. There they were destroyed in 1945, when retreating SS troops burnt down the house. The *Beethoven Frieze* survived the war only because it had not been robust enough to be moved.

Klimt's dramatic break with the state, coming in his middle age as it did, changed his way of life. He had many wealthy patrons, who continued to commission his work, and indeed when the dust had settled the State also bought his paintings. But from now on instead of fulfilling the expectations of others, he sought to please only himself. He never undertook another public commission. Matsch, by contrast, continued to work for the State, was eventually given a title, and died a successful, wealthy man.

One of the features of the exhibitions held by the Secession was that they would frequently devote the whole show to one element, a so-called *Gesamtkunstwerk*. In 1902 this element was the composer Ludwig von Beethoven, who had composed his most important works while living in Vienna. The centrepiece of the show was to be a noble statue by the German artist and sculptor Max Klinger. Klinger was famous for his monumental work, often carried out in a mixture of different stones to achieve a polychromatic effect, and he generally featured classical or biblical subjects. The statue of Beethoven (now in Leipzig Museum) was a riot of white marble, brown alabaster, red and blue marble, amber, and ivory, together with semi-precious stones, glass, and gold leaf. Such conspicuous display provided an analogy to the depiction of Beethoven not as a mere mortal composer, but as a god. Klinger enthrones the composer among imagery which alludes to Zeus, Prometheus, and even to St John the Divine.

Vienna at the turn of the century was increasingly a secular society, and it was almost as if the composer had become a substitute god, with his music regarded as offering truth and insights into the human condition.

The Secession building was refitted to take the statue, and all the other exhibits were conceived to support and enhance this central concept. Even the catalogue was designed as an integral part of the Exhibition. Klimt's contribution was a seven-part frieze symbolizing Beethoven's Ninth Symphony, which ran along three walls of the main room. On the first long wall was shown feeble mankind in the form of weak, kneeling women, imploring 'the well-armed strong one', a knight in golden armour (whom many at the time believed to be a portrait of Gustav Mahler himself, but which may also refer to as Klimt's own fight against ignorance and insensitivity) to fight for happiness, aided by Compassion and Ambition. On the short wall were the hostile powers, with whom Strength would have to battle before reaching his goal, Joy. The giant Typhon is shown as a monstrous ape, and he is flanked by the three gorgons, Disease, Madness and Death, and by Debauchery, Excess and Unchastity.

The Kiss, 1907-08 (Austrian Gallery, Vienna). Rich with gold and symbolic circles and rectangles, lifted by the bright counterpoint colours of the flowers in the little grassy meadow on which the lovers kneel in abandon, the ornament in this picture contains its whole message.

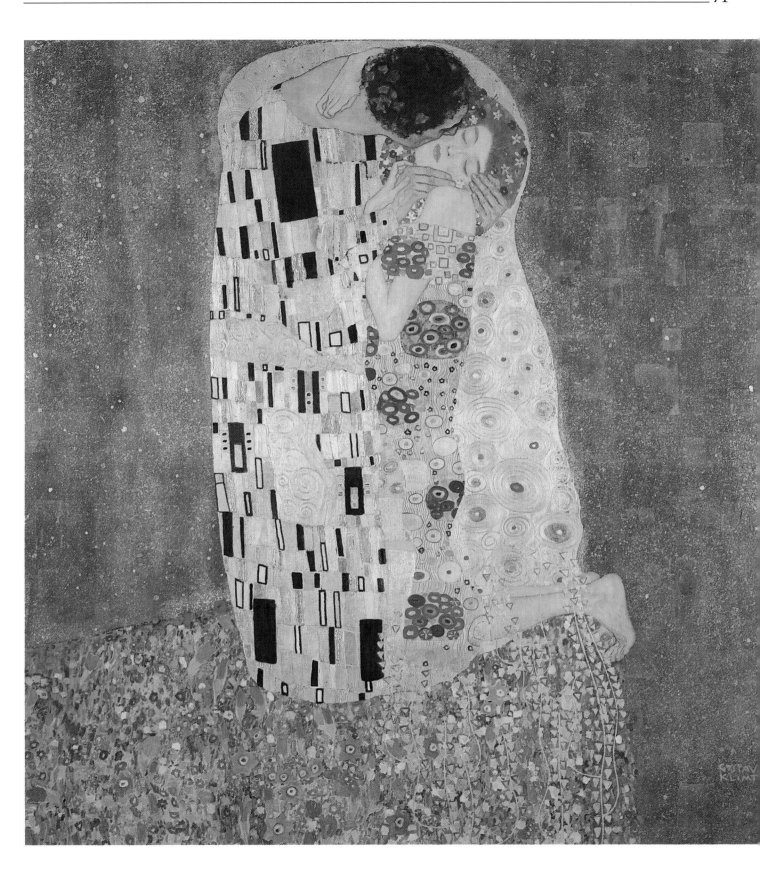

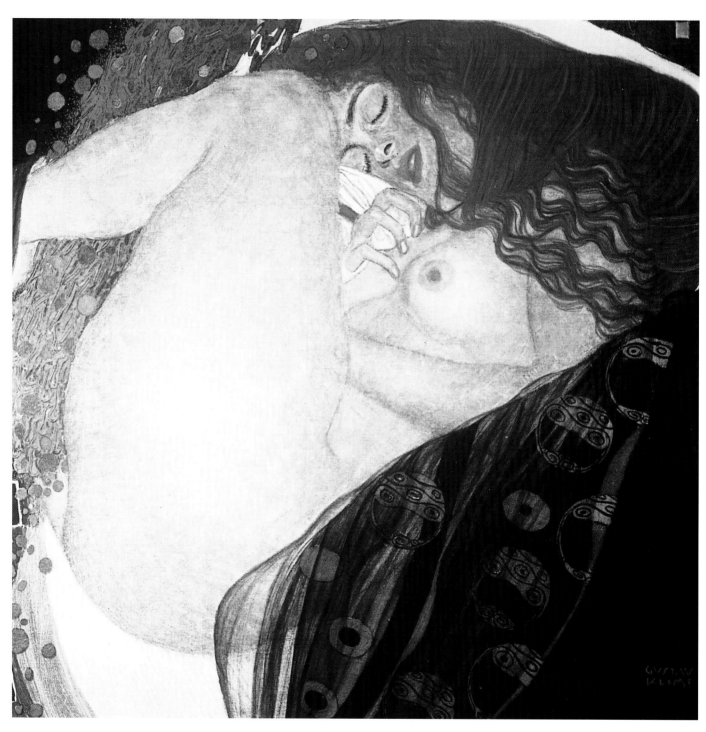

Danae, 1907 (Private collection, Graz). Flowing curves and gold leaf make this a rich, exotic version of the myth of Danae's coupling with Zeus. Danae lies self-absorbed, reducing the viewer to voyeur. Here woman is little more than the sum of her sexuality.

Excess is believed to be a tribute to the work of Aubrey Beardsley. On the second long wall Strength finds the solace of Poetry, and accompanied by a heavenly choir, arrives at pure Joy. The frieze was painted on plaster, and in it Klimt made use of gold and silver leaf, glass, mirror fragments, as well as such unexpected artefacts as nails and buttons. Its flat, emblematic treatment is the perfect foil for the brilliance of the colours and textures it contains, which in turn are heightened by the large areas of plaster left blank.

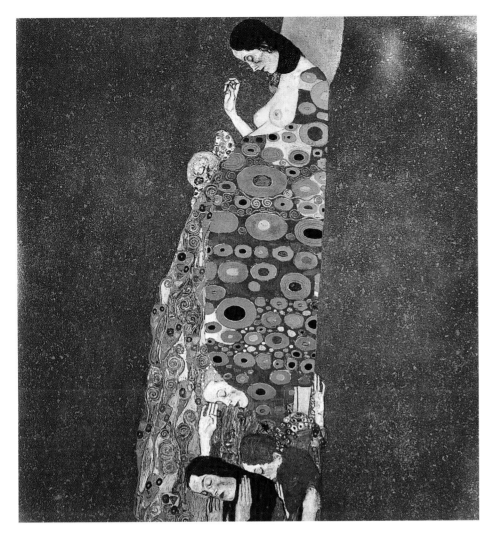

Hope II, 1907-8 (Museum of Modern Art, New York). In Klimt's second portrait of a heavily pregnant woman, he returns to his favourite format and portrays the woman robed in a brightly coloured and patterned gown. With her introspective and prayerful attitude, and those of her attendants, she symbolizes the eternal cycle of life and death.

Once again Klimt's imagery was too recondite for the majority. They looked in vain for direct references to Beethoven's music, finding only the reference to Schiller's *Ode to Joy* which the choir sings in the *Ninth Symphony: Freude, schöne Götterfunke ... Diesen Kuss der ganzen Welt!* (Joy, bright spark of divinity ... this kiss is for all the world!). Klimt's highly personal allegorical expression of the emotional impact of great music was seen instead as merely an erotic painting, and was roundly criticized. Yet the development of the work from wall to wall does echo that of the movements of a symphony, beginning simply with harmonious undulating lines, working to a crescendo of dark angles and terrifying cacophony, before reaching the calm symmetry of swirls and circles surrounding the embracing couple.

However, if the message is of salvation, it appears to be offered only through the intervention of the hero, and as in all Klimt's work, the female is seen in total submission. In the final kiss she is scarcely even visible.

The exhibition ran for three months, during which time it received almost 60,000 visitors. When it closed, the exhibits were dismantled,

and although Klimt's frieze was also intended to be disposed of, it was saved and can now be seen in the basement of the Secession Building in Vienna.

In the first years of the new century, Klimt increasingly used gold and silver leaf in his paintings. He had visited Ravenna in 1903 and was overwhelmed by his first sight of the glorious mosaics in the chapel of San Vitale. He reproduced their effect of brilliance and glitter in his paintings by filling every space with ornament, colour and metallic effects. His 1905 painting, *Three Ages of Woman*, is an allegory raised above the conventional by Klimt's rich treatment. It shows three figures, representing old age, maturity, and childhood, telling the story of the inescapable lot of humankind to grow old and, sorrowing, die. The figures are separated and emphasized by placing them against differently adorned, rich and full backgrounds.

One of the most important commissions Klimt ever undertook was his collaboration with Josef Hoffman and other members of the Werkstätte on the building and decoration of the Stoclet Palace in Brussels. The Werkstätte received the commission in 1904, and Klimt was, by his contribution to it, to prove himself a truly great decorative artist.

The work was slow and painstaking (the house was not finished until 1911), and cost Stoclet fabulous sums of money. But the house is a masterpiece, palatial, sophisticated and employing nothing but the most modern and efficient technology. Its grandest room, the dining room, was designed by Hoffmann to seat twenty-two people. Here Klimt designed a mosaic wall decoration which he himself considered the pinnacle of his development of ornament.

The mosaic, made in Vienna and installed in Brussels in 1911, is made from large quantities of precious materials – gold and silver leaf, mother-of-pearl, semi-precious stones, coral. The materials alone were extremely expensive, and Klimt lavished care and attention on his work. He himself did not actually make the mosaic; this job fell to the Werkstätte mosaic artist Leopold Forstner, under Klimt's close supervision. The mosaic consists of two panels on the long walls of the dining room, and a smaller panel on the end wall, opposite a window giving on to the garden. The two long panels contain figures, closely integrated into a Byzantine design of the Tree of Life, all rich gold loops and swirls. Indeed the unity is so complete that, with only faces and hands depicted figuratively, the nature of the two figures has been reduced to the abstract. The first figure, symbolizing Expectation, has a slightly Egyptian air, with her sideways stance and theatrically gesturing hands.

Opposite, on the other wall, is *Fulfilment*, featuring a passionate embrace. The figures stand among stylized versions of flowers, butter-flies, and birds, and the robes of the figures, rich with geometric

Judith and Holofernes I, 1901
(Austrian Gallery, Vienna). Judith gazes challengingly out of the picture, her look a mixture of ecstasy and triumph, unmistakably that of a woman at the peak of an experience. Here is the *femme fatale* that Klimt both desired and dreaded; yet he controls her image by means of the dismembering effect of her golden choker and the robe which separates her right arm from her body.

ornament, are sharply distinguished from one another. Expectation wears stripes, picked out with golden triangles, some containing Egyptian eye devices: in *Fulfilment* the man, with his back to the viewer, wears a red robe patterned with gold circles, dark rectangles, and bright birds. The girl he is kissing is, again, scarcely visible. The short end wall contains an image which appears abstract but in which some have seen a human form, reduced to pure ornament.

The decoration celebrates love, both in its use of gorgeous and sensuous materials and in its symbolic design. In its complete use of the space at Klimt's command, the work is a finely balanced decorative whole.

The image of *Fulfilment*, in itself a repeat of the kiss from the *Beethoven Frieze*, was so successful that in 1908 Klimt started work on another rendering of it, which he called *The Kiss*. This beautiful painting, probably Klimt's most famous, was executed at the height of his 'golden period' and in its lush ornamentation and eroticism has become a kind of icon of pre-war Vienna. In painting it, Klimt may have remembered seeing *The Opera of the Sea* by Margaret Macdonald, the Scottish artist and wife of Charles Rennie Mackintosh, who exhibited her painting at the Secession. Her painting was done for the music room of Fritz Wärndorfer, who was a friend of Klimt and a financial backer to the Werkstätte, and it contains an unusual floating depiction of a kiss surrounded by swirling shapes.

Klimt's painting shows a man and a woman sunk to their knees in ecstasy and a flowery meadow. They appear to be perched on the very edge of a chasm, suggesting the instability of human love and happiness. Neither of their bodies is defined except by ornament. Against a starry background, they seem enclosed in a golden halo, a device which emphasizes self-absorption and the exclusive nature of the moment. The swarthy man, crowned with ivy leaves, hungrily bends to embrace and kiss his lover. She, by contrast, appears almost disengaged. Her face, turned from her beau's lips, is peaceful and introspective, and her hands seem not to be gripping his body in ecstasy. The sumptuous ornament is laden with gold and imagery, delighting the eye and symbolizing enjoyment of all the senses. The man's robe is decorated with tall thin rectangles in black and silver, metaphors for the male: the woman's gown is rich with brightly coloured circles, metaphors for the female.

The use of curves to denote the feminine and pointed or rectangular objects to denote the male was not new, but had recently been given added publicity by the work of Sigmund Freud. Klimt's use of gold enhances the meaning of the painting by enhancing its value, and allows a choice of focus, on the content or on the form and material. Thus the painting tells an ordinary story, and its atmosphere is enhanced by Klimt's clever use of elaborate ornamentation.

Judith II, 1909 (Gallery of Modern Art, Venice). Klimt gives a Biblical gloss to a terrifying picture of a remorseless woman, bare-breasted and clawing at the hair of Holofernes. Her whole attitude is one of concentration, her sharp features echoed by the hard white triangles in her garment.

Many of Klimt's allegories concentrate on the pleasure of painting sensuously beautiful overlays on nakedly erotic images. *The Bride*, unfinished at his death in 1918, demonstrates this with literal clarity – a young girl lies with her legs spread and her sex prominent, and only after having drawn this in detail did the artist begin to paint in a rich patterned overlay.

Danae, painted in 1907, is an erotic subject given respectability by its veneer of classical allusion. In myth, Danae was impregnated by Zeus, and Klimt's painting shows her at the moment of orgasm, receiving the god in the form of a golden shower. In common with most of Klimt's paintings of this type, his subject lies self-absorbed in a stylized sleep. The flowing curves, diaphanous fabric, and rich golden ornament increase the erotic charge, and the only overt symbol of maleness are the two small black rectangles, reduced to one element among many.

Hope was a painting which Klimt knew would offend, and it was not exhibited until 1906, three years after he finished it. A naked, heavily pregnant young girl gazes steadily at the viewer, her hair a cloud of copper, and no detail of her condition spared. At first sight this seems to be merely a portrait of a pregnant woman. But looking closer it's possible to see, behind the figure and growing out of the decorated background, three strange and terrible faces, and a skull. Capable of many interpretations, one message may be that at the very moment of birth, all the sorrows of life and, finally, death are waiting. The nude figure also has erotic aspects, and powerfully arouses ambivalent feelings connected to motherhood.

Hope II is Klimt's second treatment of a pregnant woman as the main subject of a painting (pregnancies feature incidentally in various other paintings, such as *Medicine*). *Hope II* is a less ambiguous painting. The subject is bare-breasted, but robed in a gown of beautiful circles and swirling patterns. At her feet bend three women, eyes closed in patient submission. The attitude of all three, and of the pregnant woman herself, the madonna, is that of prayer, and the central theme is the eternal cycle of life and death.

Klimt painted two versions on the subject of Judith, the resolute Old Testament character who kills and decapitates the man who has murdered her husband. The first, *Judith and Holofernes*, was completed in 1901, and it is almost certain that the sitter was Adele Bloch-Bauer, with whom Klimt was having an affair. This Judith stands proudly, semi-naked and richly adorned and surrounded with golden Assyrian emblems and with jewellery. The head of Holofernes hangs from her hand, but it would be easy to overlook. Judith's parted lips and half-closed eyes tell of her moment of ecstasy and of her challenge to the viewer as a woman achieving exhilaration through the downfall of a man. Klimt had no interest in interpreting or

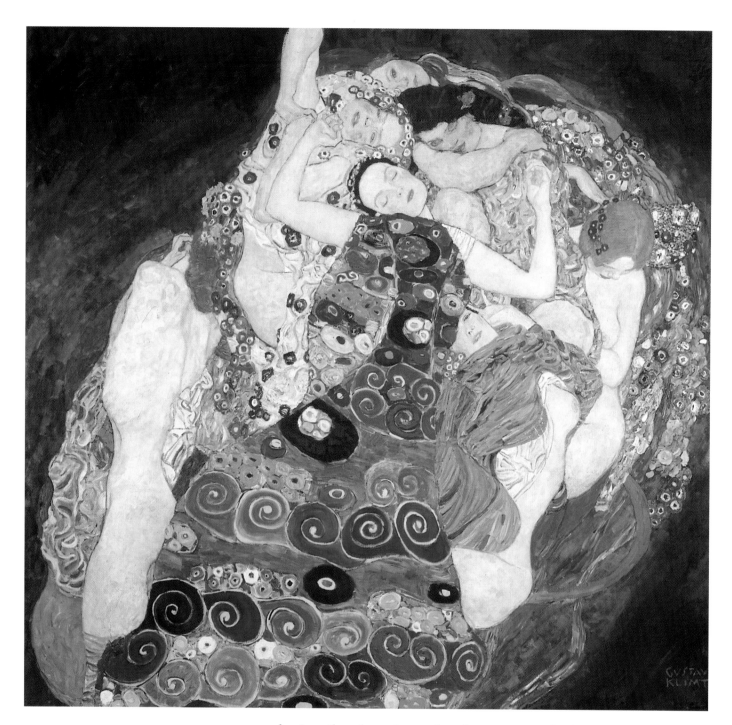

condoning the changing role of women at the turn of the century; indeed by so daringly depicting the sexuality of women he was able artistically to control it, to give it a spurious mythological context and to draw the sting of the *femme fatale*.

The titillating theme of mutilation runs through the picture, from the head of Holofernes itself, to Judith's bisected body, to the powerful effect of decapitation achieved by the use of the wide gold choker around Judith's neck. This theme is subtly carried forward in many of Klimt's allegories by such means as the frequent placing of his subjects'

heads almost at right angles to their bodies. *Judith II*, painted in 1909, is an even more terrifying depiction. Body bent as if to pounce, hands like claws with fingers rigidly clasping the hair of the dead Holofernes, her head is thrust forward and her features are sharp in feline concentration on something beyond the reach of the viewer. The picture is a vivid evocation of Klimt's complex feelings towards women, a terrible combination of fear and fascination.

After 1909 he abandoned his characteristic use of gold and silver leaf and concentrated instead on brilliant and vivid colours to create his richly ornamented overlays. His later allegories, such as *The Friends*, which was painted in about 1916, has the feel of a portrait, depicting as it does two embracing women, one naked and one robed, against a background of Oriental birds and beasts. Even though the sitters are anonymous, we are engaged by the direct gaze of the two girls and drawn to consider the mystery of their lives. The meaning of these late allegories is hard to penetrate.

The Virgin, completed in 1913, shows a young girl asleep (as in many of Klimt's allegorical paintings) but surrounded by a tangle of other young women, many semi-naked, representing desire, ecstasy, and contentment.

Klimt did not find a ready market for his late allegories. Already his art had become increasingly isolated. His had always been a style apart from that of mainstream Europe, and towards the end of his life the changes he made brought it no closer. The Futurists, Kokoschka and Schiele among them, had far outstripped Klimt's exquisite technique, and already his work appeared to belong to another age, one of optimism and extravagance, which could only, as the First World War progressed, be looked on as history. It is a curious fact that although Klimt left behind no school of painting, was considered out of date even by his own contemporaries, and appeared to have influenced no other major artist, his work is pivotal in the transition from nineteenth- to twentieth-century art. The paradoxes and contradictions in Klimt's life and in the city in which he lived are reflected in the complex paintings he has left for our interpretation. He considered himself 'not particularly interesting as a person' and said:

Whoever wants to know something about me – as an artist, the only notable thing – ought to look carefully at my pictures and try to see in them what I am and what I want to do.

The Virgin, 1913 (Narodni Gallery, Prague). The bright colours and thick brushstrokes are characteristic of Klimt's late style. The central character appears to be in a state of suspended animation, perhaps awaiting the fulfilment symbolized by the figures surrounding her.

INDEX

Adam and Eve, 44
Adele Bloch-Bauer, 47
Adele Bloch-Bauer II, 49
After the Rain, 55
Apple Tree I, 7
Arts and Crafts Movement, 28, 29
Attersee, 16, 23, 35, 36, 39, 48, 50, 56
Audience at the Old Burgtheater, 14, 26
Avenue in Schloss Kammer Park, 59

Bachofen-Echt, Elisabeth, 48, 50
Bahr, Hermann, 22, 66, 67
Beardsley, Aubrey, 72
Beech Forest I, 56
Beeches, 56
Beer, Friedericke Maria, 48
Beethoven Frieze, 26, 68, 70, 76
Beethoven, Ludwig von, 26, 70, 73
Birch Forest, 56
Black Bull, The, 55
Black Feather Hat, The, 26
Bloch, Ferdinand, 23, 35
Bloch-Bauer, Adele, 23, 35, 47, 48, 77
Brahms, Johannes, 23
Bride, The, 44, 77
Brussels, 32, 39, 74

Cabaret Fledermaus, 29
Casals, Pablo, 23
Church at Unterach on Attersee, 55
Clown on the Improvised Stage at Rothenburg, The, 36

Danae, 72, 77
Dancer, The, 36
Death and Life, 39
Degas, Edgar, 20
Dumba, Nicolas, 19, 62

El Greco, 39
Elisabeth Bachofen-Echt, 50
Emilie Flöge, 44
Expectation (Stoclet Frieze), 68

Fable, 10, 11, 62
Farm Garden with Crucifix, 59
Farm Gardens with Sunflowers, 42, 56
Farmhouse in Upper Austria, 55
Farmhouse with Birches, 55

First World War, 29, 39, 79
Fish Blood, 55
Flöge, Emilie, 29, 30, 31, 35, 36, 46, 48, 50, 52
Flöge fashion house, 29, 30, 35
Flöge, Helena, 29, 35
Flower Garden, 56
Forstner, Leopold, 74
Franz Josef, Emperor, 10, 12, 14, 22, 30, 32
Freud, Sigmund, 11, 76
Friends, The, 79
Fritza Riedler, 46
Fulfilment (Stoclet Frieze), 69, 74, 76

Garden Path with Chickens, 55
Gauguin, Paul, 32
Gerlach, Martin, 19
Girl Friends, 32
Girl from Tanagra, 16
Golden Apple Tree, The, 56
Golden Knight, The, 26
Goldfish, 64, 67

Henneberg, Marie, 44
Hermine Gallia, 31, 47
Hevesi, Ludwig, 65, 67
Hoffman, Josef, 20, 28, 29, 30, 33, 34, 44, 74
Hope I, 32, 35, 77
Hope II, 73, 77

Idyll, 62
Interpretation of Dreams (Freud), 11
Island on the Attersee, 56

Judith and Holofernes, 35, 75, 75, 77
Judith II, 16, 32, 35, 76, 78
Jurisprudence, 26, 68

Khnopff, Fernand, 21, 34, 52
Kiss for the Whole World, A, 62
Kiss, The, 32, 59, 70, 76
Klimt, Anna, 12, 39
Klimt, Ernst (jnr), 12, 14, 19, 29, 36
Klimt, Ernst (snr), 12, 19
Klimt, Georg, 12, 22, 64
Klimt Group, 30 , 59
Klimt, Gustav, early years and Künstlercompagnie, 12-19; Secession, 20ff; Klimt Group, 30-32; erotic drawings, 42-44; portraits, 44-48; land-scapes, 48-59; allegories, 50-79
Klinger, Max, 70
Knips, Sonja, 22, 23, 52
Kokoschka, Oskar, 30, 34, 79
Künstlercompagnie, 14, 19
Kunstschau Wien, 30, 33

Lady with Hat and Feather Boa, 26
Lederer, Auguste, 23, 26, 68
Lederer, Serena, 23, 48
Lewinsky, Josef, 44
Love, 19, 62

Macdonald, Margaret, 76
Mackintosh, Charles Rennie, 20, 28, 44, 76
Mäda Primavesi, 44
Mahler, Gustav, 11, 23, 26, 35, 70
Makart, Hans, 12, 14, 16, 62
Manet, Edouard, 20
Matisse, Henri, 32
Matsch, Franz, 12, 14, 19, 20, 23, 26, 62, 68, 70
Medicine, 26, 42, 62, 67, 68, 77
Mermaids, 55
Minne, Georges, 34
Moll, Carl, 36
Monet, Claude, 55
Morris, William, 20, 29, 32
Moser, Koloman, 28, 68
Munch, Edvard, 32
Munk, Ria, 36
Museum of Art History, 16, 26, 52, 62
Museum of Modern Art, 21, 68
Music I, 19, 21
Music II, 19

Nähr, Max, 36
Nebehay, Gustav, 42
Ninth Symphony (Beethoven), 26, 70, 73
Nuda Veritas, 65, 67

Ode to Joy (Schiller), 73
Olbrich, Josef, 20
Opera of the Sea, The (Macdonald), 76
Orchards and Farmhouse with Climbing Rose, 23, 50

Pallas Athene, 16, 22, 64
Park at Schönnbrun, 59
Park, The, 56, 59
Pembauer, Joseph, 44
Philosophy, 26, 50, 62, 65, 67, 68
Picasso, Pablo, 34
Primavesi, Eugenia, 48
Primavesi, Mäda, 48
Primavesi, Otto, 23, 44, 48

Ravenna, 39, 74
Reform Movement, 30, 35, 36, 48
Reininghaus, Carl, 68
Renoir, Pierre-Auguste, 20
Riedler, Fritza, 47
Rilke, Rainer Maria, 22
Rodin, Auguste, 21
Romeo and Juliet (Shakespeare), 16
Rose Bushes under Trees, 28

Rosthorn-Friedmann, Rose von, 22
Ruskin, John, 20

Sargent, John Singer, 21, 44
Schiele, Egon, 32, 34, 48, 79
Schiller, Johann, 65, 73
Schindler, Anna, 35
Schloss Kammer on the Attersee I, 52
Schloss Kammer on the Attersee III, 16
Schubert at the Piano, 19, 35, 62
Sculpture, 62
Secession, 20, 21, 22, 23, 26, 27, 28, 30, 32, 34, 50, 54, 56, 59, 62, 64, 65, 68, 70, 76
Second World War, 29
Seurat, Georges, 52
Signac, Paul, 52
Sonja Knips, 14, 36, 44
Stoclet, Adolphe, 32, 33, 34, 74
Stoclet Frieze, 5, 34, 39
Stonborough, Thomas, 47
Stonborough-Wittgenstein, Margaret, 47
Sunflower, 57
Swinburne, Charles Algernon, 22

Three Ages of Woman, The, 67, 74
Tragedy, 62

University of Vienna, 23, 24, 26, 44, 50, 62, 65, 67, 68

Van Gogh, Vincent, 32, 52, 56, 59
Velazquez, Diego Rodriguez, 47
Ver Sacrum, 20, 22, 42, 65
Vienna School of Arts and Crafts, 12, 14, 19, 50
Viennese Co-operative Society of Austrian Artists, 20, 21
Virgin, The, 79

Wagner, Otto, 11
Wärndorfer, Fritz, 76
Water Nymphs (Silverfish), 18, 22
Water Serpents, 55
Water Snakes I, 42
Water Snakes II, 13, 43
Waterlilies (Monet), 56
Whistler, James Abbott McNeill, 21, 22, 44, 55
Wiener Werkstätte, 28, 29, 30, 32, 44, 74, 76
Wittgenstein, Karl, 23
Wittgenstein, Ludwig, 23
World Fair, Paris, 26, 67
World Fair, St Louis, 26, 68

Youth, 62

Zimmerman, Mizzi, 35, 50

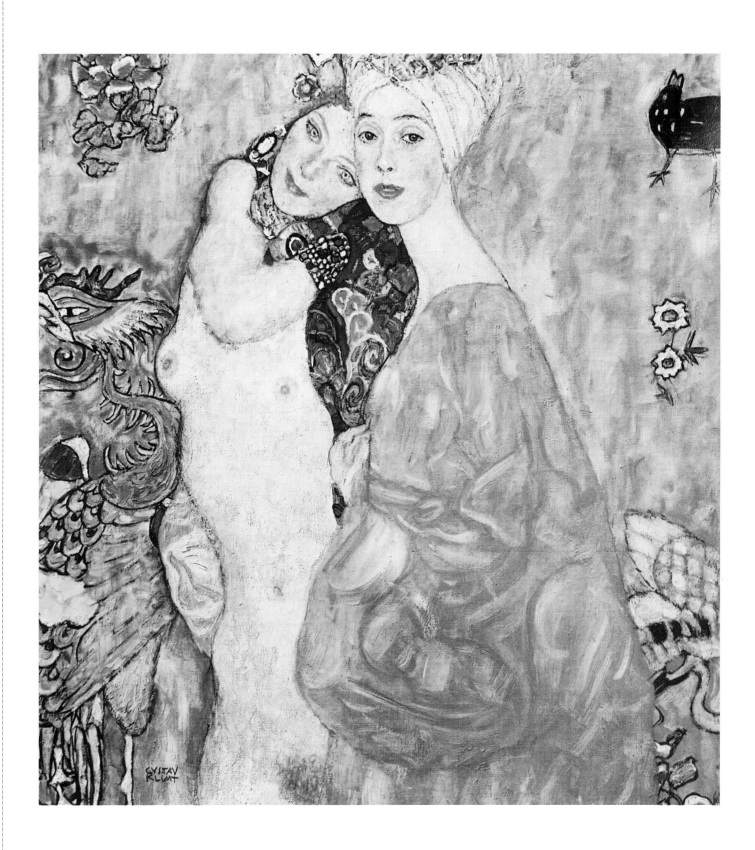

Klimt. Girl Friends, 1916-17
(destroyed by fire 1945)

Klimt. Woman's Head, 1917-18 (unfinished)
(Wolfgang-Gurlitt-Museum, New Gallery of the City of Linz)

Klimt. Water Snakes I, 1904 (detail)
(Austrian Gallery, Vienna)

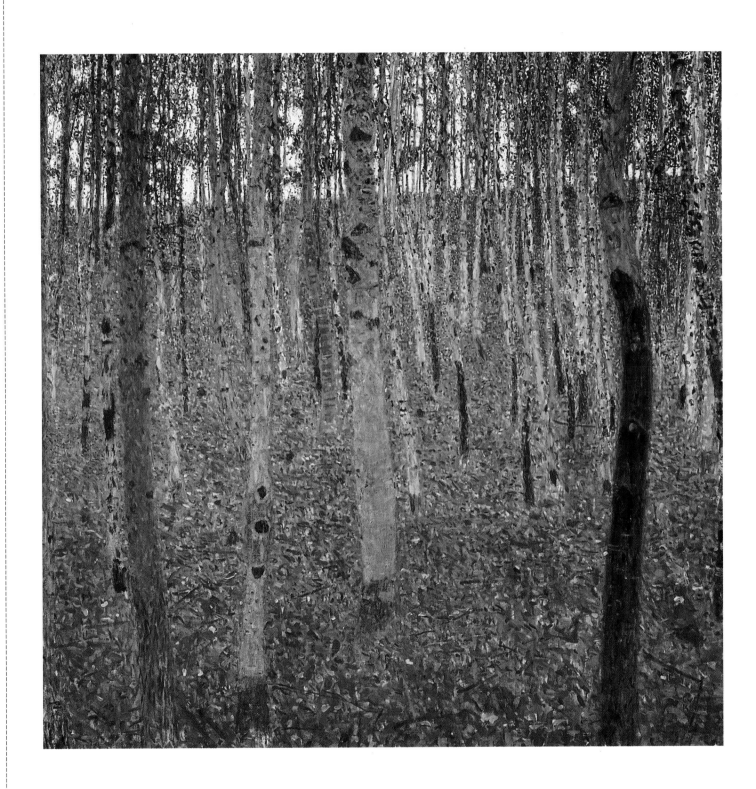

Klimt. Birch Forest, 1905
(Gemaldegalerie, Dresden)

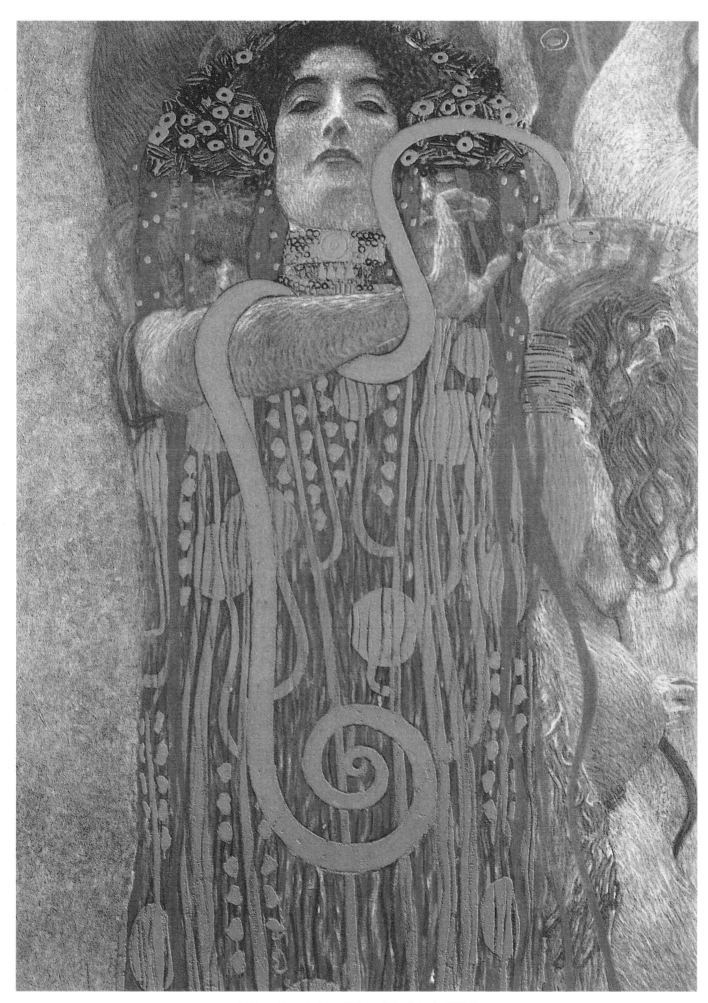

Klimt. Hygeia (detail from Medicine), 1900-7
(destroyed by fire 1945)

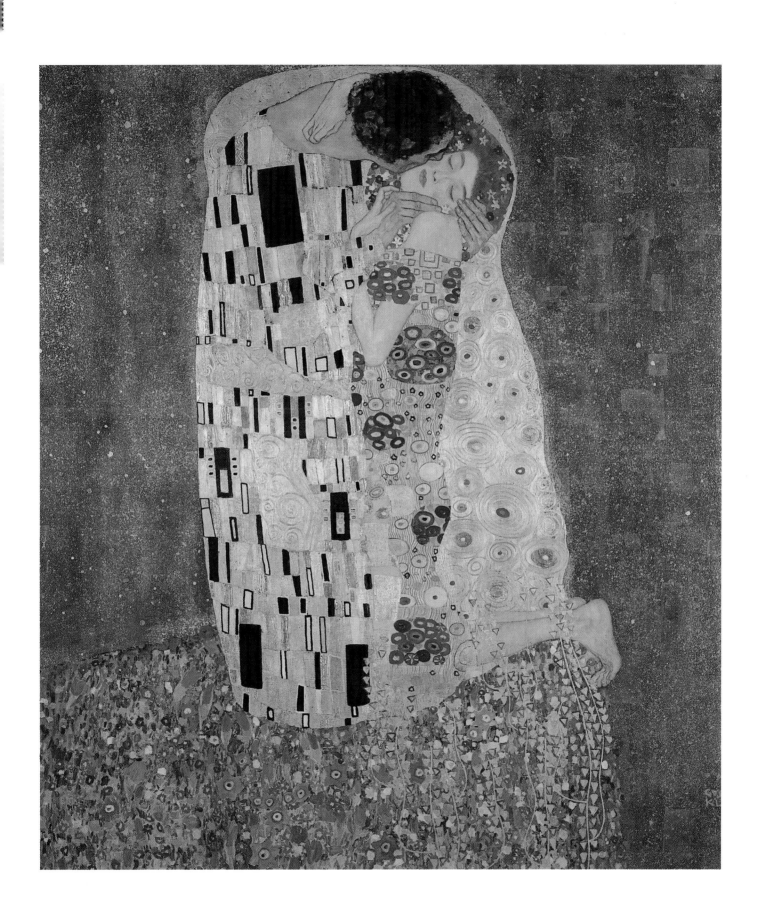

Klimt. The Kiss, 1907-8
(Austrian Gallery, Vienna)

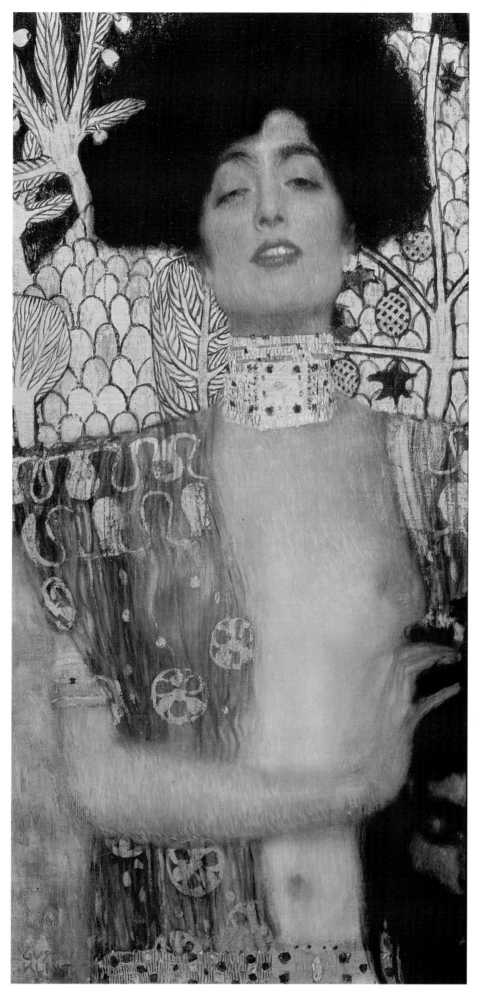

Klimt. Judith and Holofernes I, 1901
(Austrian Gallery, Vienna)

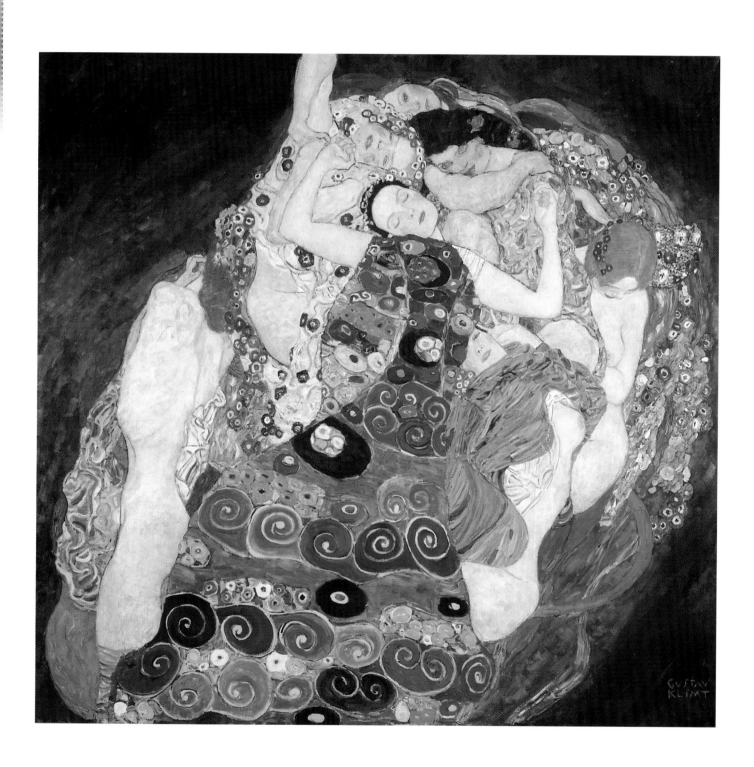

Klimt. The Virgin, 1913
(Narodni Gallery, Prague)